CONVERGENCE DESIGN

ROCKPORT

GLOUCESTER MASSACHUSETTS

ROCKPORT

PUBLISHERS

CONVERGENCE DESIGN

Creating the

User Experience

for Interactive

Television,

Wireless, and

Broadband

STEVE CURRAN

First published in the United States of America by

Rockport Publishers, Inc.

33 Commercial Street

Gloucester, Massachusetts 01930-5089

Telephone: (978) 282-9590

Fax: (978) 283-2742

www.rockpub.com

Library of Congress Cataloging-in-Publication Data

Curran, Steve.

 Convergence design : creating the user experience for interactive television, wireless, and broadband / Steve Curran.

 p. cm.

 ISBN 1-56496-904-5 (hardcover)

 1. Interactive television. 2. Internet—Social aspects. 3. Mass media—Forecasting. 4. Convergence (Telecommunication) I. Title.

TK6679.3 .C87 2003

303.48'33—dc21 2002011281

ISBN 1-56496-904-5

10 9 8 7 6 5 4 3 2 1

Design: John Hall Design Group
www.printlives.com

Cover Design: Steve Curran
Cover Resource Image: Eyewire

Printed in China

Dedicated with all my love
to Liz, Jake, and Christopher

CONTENTS

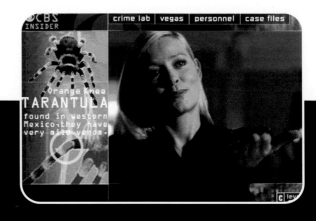

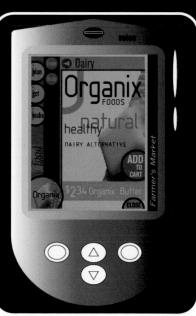

INTRODUCTION

The idea behind this book is quite simply to feature a collection of inspired design work and content creation that has taken place inside the chaos of colliding media. From brilliant navigation systems on a large screen to addictive entertainment on a screen the size of a watch face, creative designers and content producers are defining the future of narrowband, broadband, and wireless communications. >> Someday, this book might be found in a used bookstore and appreciated as a relic of naïve futurism as it shares shelf space with antique copies of *Popular Mechanics* and 1939 World's Fair programs boasting of "the world of tomorrow." >> By the time this book is published, some of these projects will have failed, and some of the companies that did them will have shut their doors. But hopefully, the design principles and philosophies, ideas and approaches, successes and failures of the projects will inform and prove relevant to designers of convergent media for many years to come. >> What drives these creators as they work in the cross fire of prototypes, market tests, and unproven markets? By most accounts, it isn't fame or fortune. For many, the excitement and passion come from being involved in the invention of a new visual language. >> The design of interactive media is a living language, and a living language is a work in progress, constantly in a state of change. And while interactive technology evolves at a dizzying pace, the grammar of this visual language evolves much more slowly. A sense of visual etiquette develops as a way to ease users across bridges to new mediums, technologies, and environments. >> In Jean-Claude Carrière's excellent book *The Secret Language of Film*, there is a passage that neatly illustrates the collaborative and evolutionary processes that take place in the development of a "visual dictionary": >> **All expression—pictorial, theatrical, or merely social—lives on acknowledged or unacknowledged memories, personal reminiscences, a private or communal treasury ▶**

▶ that glitters brightly for some and less so for others. And everyone finds his voice, his stance, or his coloration in these deep woods we all inhabit—a stance and coloration, which others will one day rediscover and remember. >> The Cinema made lavish use of all that had gone before. When it was given speech in 1930, it called on the services of writers; when color came along, it enlisted painters; it turned to musicians and architects. Each contributed his own vision, his own voice.... >> And it was through the repetition of forms, through daily contact with all kinds of audiences, that the language took shape and branched out, with each great filmmaker in his own way enriching the vast visible dictionary we all now consult. It is a language that goes on changing week by week and day by day, the swift-moving reflection of those obscure, many-faceted, complex, and contradictory relationships that are the unique connective tissue of human societies. >> What continues to motivate designers and content developers is the challenge, opportunity, and excitement they find in developing the mediums to improve the experiences of users. And with that role comes the fundamental responsibility of delivering on the promise that digital convergence will change (ideally for the better) the way we communicate, work, play, and live. >> Every success in this book is built on the shared experiences of the hundreds of projects and companies that failed before it. The road to convergence is littered with great ideas that failed because they were ahead of their time, faced technological or economic barriers, or were in some respect fundamentally flawed from the start. >> There have been brilliant executions of bad ideas and bad executions of brilliant ideas. And every once in a while, a smart idea is smartly executed, the consumers and audiences respond, and the medium moves forward. >> I hope that inside this book you'll find examples that inspire you to do the same. ⊃

Steve Curran

OVERVIEW

By Robert Greenberg
Founder, Chairman, and Chief Creative Officer, R/GA Interactive

Designing for Convergence:
Opportunities for Innovation

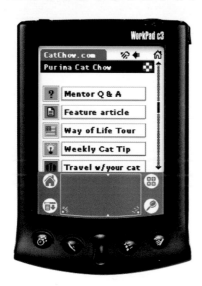

Even though the Information Age is in its infancy, the convergence of narrowband, broadband, and wireless is leading to exciting opportunities for designers to create innovative interfaces for commerce and communication. The growing reliance on technology and the abundance of information have created a world that is increasingly complicated, but because designers so skillfully reduce complex concepts into simple, understandable elements, the business community will be able to capitalize on the opportunities to reach consumers that these new technologies afford. Over the next few years, emerging technologies and global standards will pose the greatest challenges for designers in their quest to build new bridges between producers and consumers.

The development of global digital standards has given designers a framework for creating large-scale projects and the freedom to customize designs for localized programs. The key to globalization is creating consistent visual messaging across the growing number of distribution channels—narrowband, broadband, wireless, print, broadcast, and direct. A successful project requires the designer to create scenarios for one medium that also allow that brand experience to be repurposed across multiple platforms by using a common pool of creative concepts and production assets.

This cross-media expertise requires the integration of good design principles with knowledge of the technical and database implications. The exclusivity of the platform designs of recent ▶

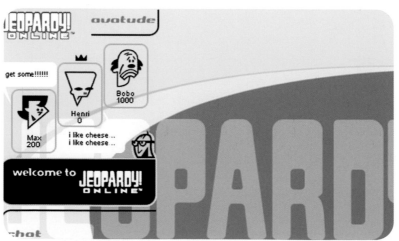

technologies and the current lack of a standardized data format have created for today's designers many challenges in integrating the multiple distribution channels with the disparate databases, software programs, and applications.

But one thing technology does permit is measurement. At present, there are limited—if any—reliable feedback mechanisms to determine design return-on-investment parameters. This will change. User experiences will be translated into measurable results, and clients will require these metrics when evaluating digital design projects.

Successful convergence projects also demand of designers a number of essential elements, including expertise in digital video, computer graphics, audio, and copywriting.

Why and how is digital video being used? As the Information Age progresses, streaming video will become a justifiable, meaningful addition to projects. The challenges for designers will be to construct motion or video elements that fit into the overall brand campaigns and to learn the intricacies of designing for video rather than for static images.

Computer graphics designers of the future will create two-dimensional/three-dimensional graphics that can be repurposed across different media platforms. In addition, with the advent of computers have come trends such as using computer-simulated spokespeople and developing 3-D animated characters and products.

Effective and innovative ways of employing sound are just beginning to emerge. One example is voice activation of car phones, and remote activation is sure to expand to other products as the trend continues. Another example is "sonification"—using a sound as a brand tenet, an element of the brand's identity. This will become an integral component in defining brands online and might include associating a specific tone or piece of music with the brand. The current challenge lies in developing music for the Web that adds to the online experience, rather than detracts from it.

Copywriting for the Web is becoming an art of its own. Although Web copywriting has long been associated with traditional advertising, the Internet demands the use of an entirely new set of parameters. These include creating new standards, using words differently, placing upper- and lowercase letters in unusual positions to create emphasis, and developing rules for using color online.

Collaboration with technical and programming colleagues will also become increasingly important for designers, because as projects become more complex, a growing number of parties are involved in the process. In some cases, the designers will execute the entire project, but in others they will perform only a portion of the overall job. Having the ability to work effectively with sister-company employees or other outside parties to develop these complex communications programs will be essential for designers who want to integrate sound, motion, and computer graphics into their projects. ⌡

C INTERACTIVE TELEVISION

The (pizza) pie-in-the-sky future

When it comes to fulfilling the promise of interactive television, the future is getting here—it's just a few years behind schedule.

For years we've heard that interactive television—or iTV, as it's known—will give us a five-hundred-channel universe souped up with such PC-like features as chat, E-mail, multiplayer games, and t-commerce capability so you can order products via your television. Likewise, no iTV conference or article has been complete

without someone presenting holy grail visions of being able to order the sweater Jennifer Aniston is wearing while you're watching *Friends*, or ordering pizza-on-demand. These scenarios are used to illustrate the future of iTV, when a user will simply point and click—on impulse, perhaps—to purchase a product, have it sent automatically, and be billed for it using information already on file with the cable operator.

Industry enthusiasm, however, has waxed and waned with every market test and technological advancement over the last fifteen years. Dale Herigstad, who's been involved with interactive television since tests in the early 1990s, has seen first-hand how the iTV future always seems like a mirage on the horizon, disappearing as you get closer. "In the early 1990s," he says, "I was involved in some of the big Time Warner tests that were taking place, and the attitude was 'it's coming.' But here we are, twelve years later, and the attitude is still 'it's coming.'"

Part of the reason it's taken so long in the United States is that there has been a lot of confusion, particularly on the part of cable operators (MSOs, or multiservice operators) about how to make money with iTV. Interactive television in Europe is a more streamlined system, with the content for a project being created, owned, and distributed all by the ▶

same company. In the U.S., the antitrust regulations that prevent industry monopolization also contribute to the complexi-ties of establishing a single set of standards, or platform.

As a result, users in the United Kindom and France are comfortably using interactive television to shop at Harrods, perform bank transactions, play video games, and yes, even order pizza. In the United States, the enthusiasm over elec-tronic programming guides (EPGs) and video-on-demand are seen as benchmarks of public interest in interactive services.

While an entire book could be written about the business and technology obstacles preventing interactive television from moving forward, this book focuses on user interaction, the front line of consumer adoption. At the end of the day, success or failure for iTV rides on whether a consumer can pick up a remote control, instinctively understand where they can go and what they can do with interactive television, and, once there, find that value has been added to the passive experience. iTV must make a more emotional connection with viewers than can be made by simply slapping interactivity on precanned content as an afterthought.

Making a dumb appliance smarter

The problem facing designers during this larval stage of iTV is that interactive services require them to take one of the simplest, easiest-to-use appliances on Earth, one that people are eager to use when they are in the mood to be mindless, and add complexity. iTV designers *start* with strikes against them. For the user, the end value of the experience must clearly outweigh the additional complexity. In Europe for example, OpenTV whetted the appetite for their interactive services by offer-ing customers a suite of easy-to-use services that drew them in and invited experimentation. Offering "soft" interactive services such as horoscopes, news, weather reports, and games laid the groundwork for later upgrades that proved popular.

In the early days of the Internet, its low barrier of entry prompted a creative stampede to invent the medium. Any creator armed with a dial-up connection, Photoshop, and a WYSIWYG Web-page editor could immediately become part of the Internet's creation. This bottom-up process pushed new, innovative, and surprising content and tools into the hands of the public far more efficiently than technologists and corporations could have. But iTV's barrier of entry is high, and technol-ogy and infrastructure requirements, the delay between the time a work is produced and when it gets to market, and the expense of training and licensing developers and procuring equipment prevent a wider circle of creators and innovators from shaping the medium.

As a result, many of the first wave of companies that have been creating interactive television have been primarily tech-nology companies. Because of the myriad platform issues, technical complexities, and limitations on R&D budgets at design firms, only a few have been brave enough to focus their efforts on designing the user interface for interactive television.

The design firms featured in this book have been working with iTV as an extension of their existing broadcast design and produc-tion businesses. For them, iTV experience is an investment in the future. Of the various types of design firms positioned to make the transition to these new mediums, interactive firms are the logical choice for success because they have skill, experience, and knowl-edge in designing for interactive mediums. But interactive firms have sometimes found it difficult to apply Web design practices and standards to iTV. So far, broadcast design firms have had an easier time of making television interactive than interactive firms have had of bringing interactive skills to television. The difference lies in the fact that broadcast designers have insight into the context of the medium and respect the fact that TV, for better or worse, still occupies a hallowed place at the center of our living rooms, homes, and lives. ⊐

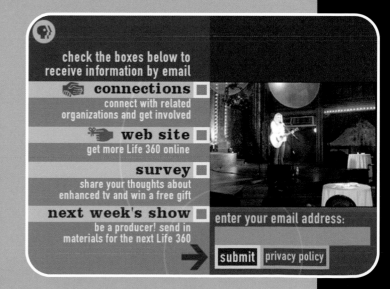

H DESIGN

Many times, the design firms that develop the interactive experience for projects are dealing with content that has already been produced by someone else. The role of the design firm in that situation is to create the best possible environment, navigation scheme, and presentation for the content. But the best examples of iTV have been produced when the content is developed by or in cooperation with the designers responsible for creating the interactive experience. The result is a seamless blending of content and interactivity. ▶

Creating content from the inside out

Client > CBS/*C.S.I.: Crime Scene Investigation* **Developer >** H Design
Platform > Microsoft iTV **Project Title >** *C.S.I.* Interactive

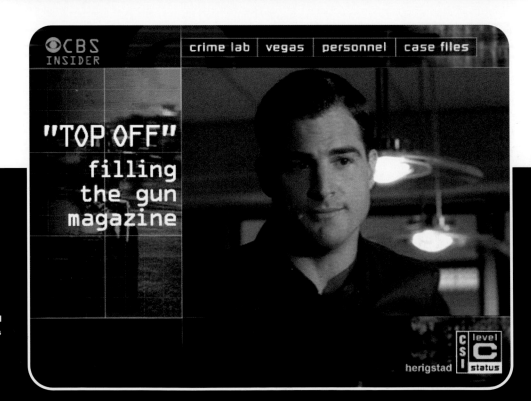

(RIGHT) **The show uses plenty of law-enforcement and medical jargon, but definitions that can be called up with the interactive version ensure that viewers will be in the know.**

[Challenge] H Design was asked to create on the Microsoft iTV platform an interactive, enhanced experience as companion content for the CBS series *C.S.I.*

The *C.S.I.* project offered H Design a unique opportunity for an interactive design firm: a chance to play an integral role in the development of content. While the firm was not involved with the show itself, the project allowed them to conceptualize the feature set and framework for the iTV component and to write, produce, and design original interactive content for all twenty-four episodes. The team worked with CBS's visionary programming leader, David Katz, and Jerry Bruckheimer's Alliance Atlantis for the entire first season to create deep content that worked hand in hand with the hit broadcast show. ▶

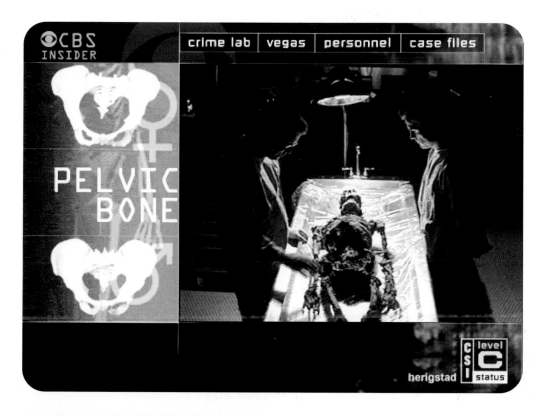

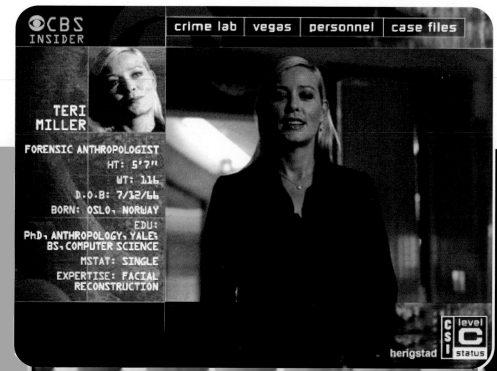

Dale Herigstad > **Creative Director**
Robert H. Sanborn > **Executive Producer**
Mickey Worsnup > **Producer**
Robert Howell > **Lead Designer**

(ABOVE) **In this scene, the investigators are discussing how to identify the sex of a victim by the shape of the pelvis. The visuals available with the interactive version illustrate the difference.**

(LEFT) **A profile of a character on the show offers her "vital statistics," in keeping with the show's investigatory theme.**

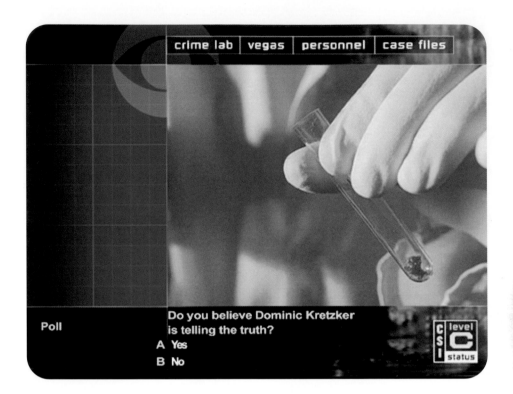

crime lab | vegas | personnel | case files

Poll

Do you believe Dominic Kretzker
is telling the truth?

A Yes

B No

CSI level **C** status

(LEFT AND BELOW) **Live,
dynamic polls conducted
at critical points in the
show allow viewers to
voice their opinions and
establish a sense of
community interaction.**

[Solution] When graphic content must be combined with the video screen, typically the video portion is reduced in size and surrounded by graphics on three sides. This commonly used format has become known among iTV designers as the "L" design, and it has a downside: the video portion often seems to have been shoved aside to make room for the interactive features.

H Design created a unique experience layer around the show by breaking away from the traditional "L" design of previous applications, focusing on the customized enhancements to the stories, and then incorporating them in a format that made the elements work together as a whole. ▶

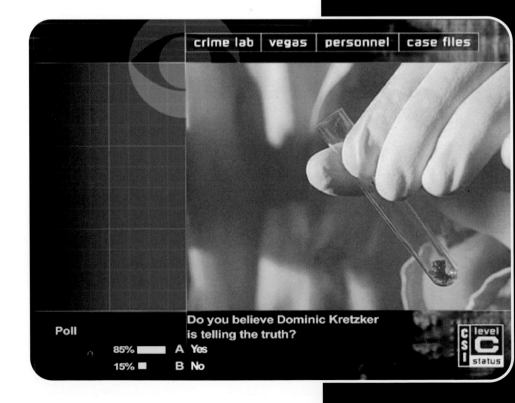

crime lab | vegas | personnel | case files

Poll

Do you believe Dominic Kretzker
is telling the truth?

85% ▬ A Yes

15% ■ B No

CSI level **C** status

(BELOW) **A gun is identified by brand name and model. Background details like this can provide important clues, allowing viewers to participate in the investigation. Or, they may be useless facts that help to throw viewers off the track.**

The first task was to create a template for the application in order to simplify the creation of enhancements for the twenty-four one-hour episodes. A simple letterbox format places graphical content adjacent to the video. Much of this content is presented to the viewer in a carefully choreographed manner that enhances the story line of the show by providing, for example, a sense of place, explanations of forensic techniques shown, or detail shots of scenes for closer observation. Viewers can "pull" additional content like cast-member bios, maps of locations around Las Vegas (the setting of the show), information on specific forensic techniques and terminology, and synopses of previous episodes. ▶

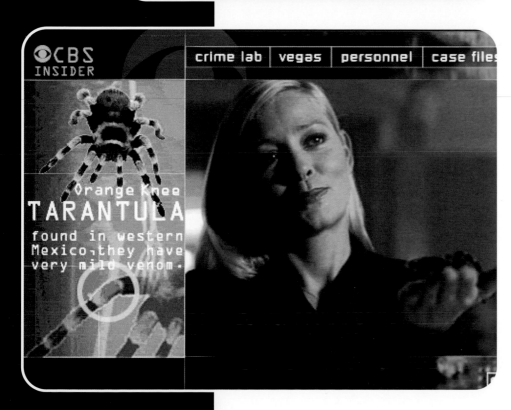

(LEFT) **A tarantula is identified by variety, characteristics, and location found.**

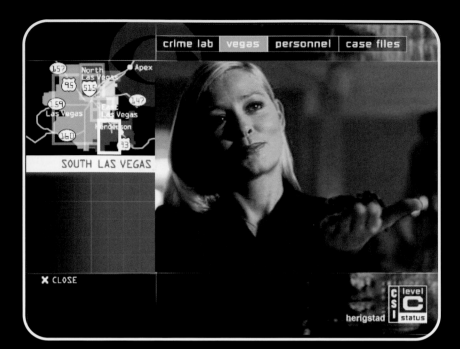

(LEFT AND BELOW) **These screens show real, navigable maps of Las Vegas (the show's setting). These add realism to the show, because users can see in real time the locations where the action is taking place.**

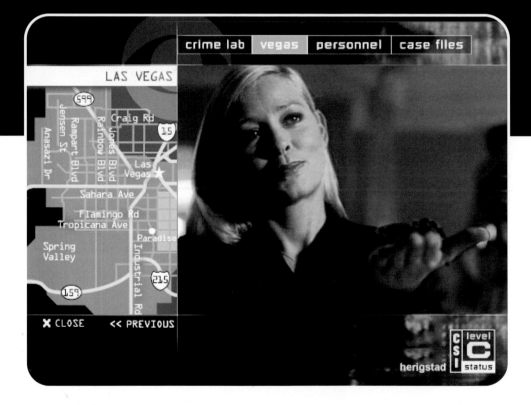

To provide a gamelike experience, viewers can participate in the investigative process by answering questions presented in the lower part of the screen. When multiple-choice questions are answered correctly, points are awarded, and the user's ranking (indicated at lower right on the screen) within the pool of all users may change. The results of polls are shown graphically, promoting a sense of community and viewer involvement in the program.

The interface, colors, and graphic choices for the iTV component extend the neo-noir and high-tech look and feel of the broadcast show, and its content and design allow the user to dig more deeply into the broadcast show's content. ⌐

(RIGHT) **This menu provides a selection of information on the equipment, facts, techniques, and terms associated with a forensic lab. The design firm provided the thumbnail visuals for easy navigation.**

(BELOW) **From the equipment menu, users go to a submenu of crime-lab tools. Selecting an object calls up a quick overview of how that tool is used in crime investigation. The iTV version presents a deeper level of detail that would have interrupted the dramatic flow if it had been explained on the show.**

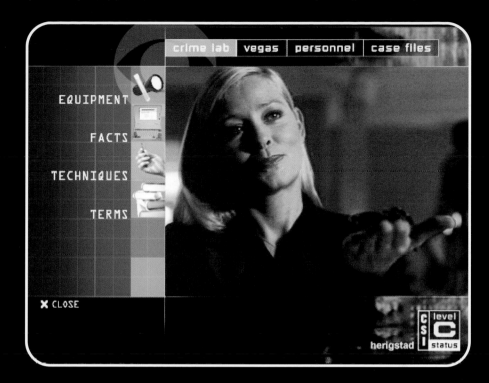

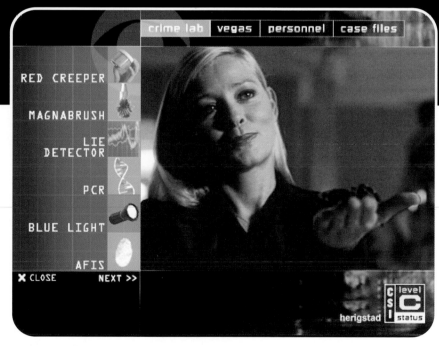

(BELOW) **Selecting one of the tools provides a close-up look and a description of the item's function and value for the investigators.**

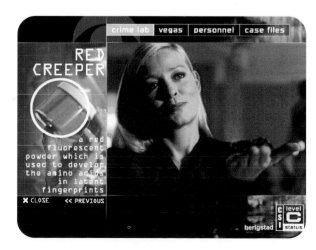

One criticism of iTV is that too few cases have seen original content enhanced or improved by adding interactive features. While offering additional information and merchandising does add value to a program, the medium is ripe for projects that take advantage of iTV's potential to create a more personal, relevant experience that transforms the passive user into an active participant in a community. Expectations are high for the Public Broadcasting System (PBS) to lead the way with high-quality, noncommercial, educational interactive programs with regional relevance and localized content. ▶

(RIGHT) **The main menu lists some of the additional materials the user can opt-in for, as well as a link that lists the relevant local organizations the user can get involved with. The design's playful combination of typefaces and icons set against a muted, organic color scheme works well in conjunction with the "antiglitz" appeal of the programming.**

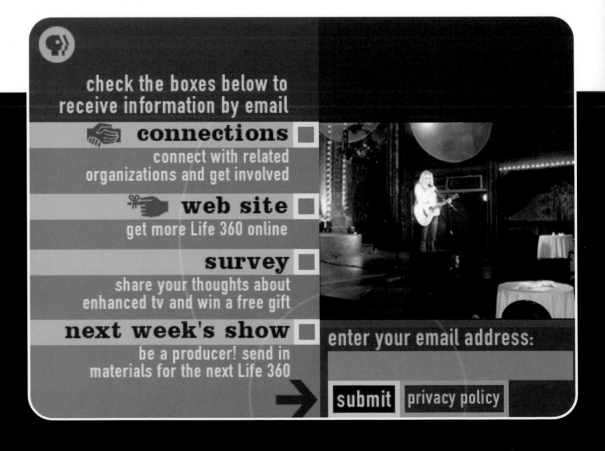

check the boxes below to receive information by email

connections
connect with related organizations and get involved

web site
get more Life 360 online

survey
share your thoughts about enhanced tv and win a free gift

next week's show
be a producer! send in materials for the next Life 360

enter your email address:

submit privacy policy

Dale Herigstad > **Creative Director**
Robert H. Sanborn > **Executive Producer**
Mickey Worsnup > **Producer**
Robert Howell > **Lead Designer**

[**Challenge**] PBS, ABC News *Nightline*, and Oregon Public Broadcasting (OPB) were looking to produce compelling, enhanced interactive content for all thirteen episodes of PBS's new prime-time biography series, *Life 360*. *Life 360*, a timely, reflective show hosted by the Emmy-award-winning ABC News *Nightline* correspondent Michel Martin, was created by a team of seasoned professionals from both OPB and *Nightline*. Each sixty-minute program in this innovative series explores intriguing themes like the Vietnam War and fire fighting through a dynamic mixture of segments that draw on the storytelling of today's best and brightest independent filmmakers, writers, comedians, musicians, performance artists, and journalists. The concept for the interactive-enhanced version was to connect viewers to the events, organizations, and resources in their own communities that relate to the episode's topic. ▶

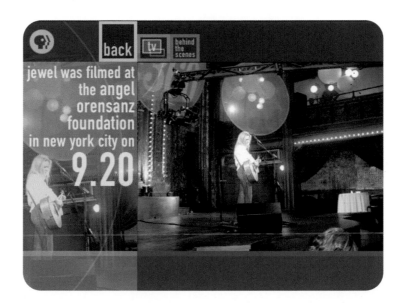

(LEFT) **The user can watch the broadcast while also viewing factoids or options for visiting "behind the scenes," where other camera views reveal different aspects of the broadcast's production. In this example, the artist Jewel was filmed from multiple camera angles at an Angel Orensanz Foundation concert in New York City.**

(RIGHT) **An interactive map of Vietnam allows viewers to navigate between Hanoi and Saigon. By consistently filling the left side of the screen from top to bottom with imagery, the grid design is employed in a manner that feels more like a split screen than an L shape framing the video.**

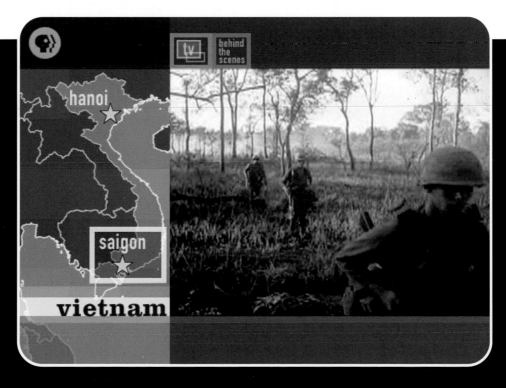

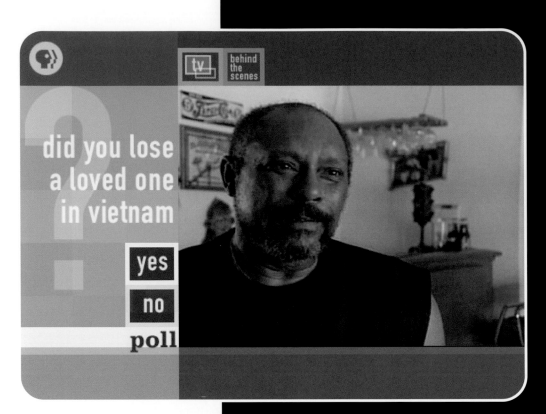

(TOP LEFT AND CENTER) **An interactive viewer poll on an emotional topic brings home the regional and personal tolls of the Vietnam War.**

(BOTTOM) **On the left side of the screen is additional information about the soldier being profiled. In this example, the information associates the subject with his home community.**

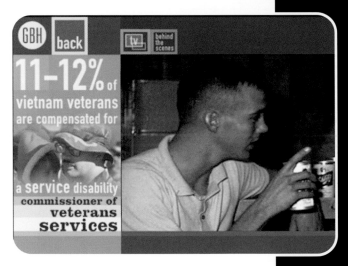

[**Solution**] To make the *Life 360* project accessible on as many interactive platforms as possible, PBS initiated an unprecedented coproduction partnership between broadcasting companies, local public stations, and many of the leading interactive platform companies, including Microsoft TV, Sony Electronics, and DirecTV. H Design was charged with the lead role in conceiving and designing the interactive feature set and presentation, as well as a "toolkit" that would allow local stations to create, build, and broadcast localized content inside the framework of the national show. These templates and tools allowed community-related content to be built around each episode with inter-activity customized to the individual markets. The enhanced experience is available throughout most of the U.S. and can be used on almost every iTV platform. The design uses neutral grays and cool colors for the backgrounds of interactive elements and factoids, allowing the human drama of the video to stay front and center.]

firefighter at
engine co.
235

brooklyn
new york

nick
chiofalo

[ABOVE] **The designers created a grid that allows the left side of the screen to be used for interesting side information, giving the viewer a deeper understanding of the content. In this example, the interviewee's name and fire company number appear beside him in a show about**

When designing menus and navigation systems for television-based applications, one of the biggest hurdles to overcome is the lack of on-screen real estate. Television's image resolution is lower than that of computers, so larger fonts and menus must be used. While designers may be tempted to strip down menus to a few essential buttons, they should remember that users find it tiresome to have to navigate with a remote control through multiple layers of menus or to have to return to the home page simply to find options. The most innovative menu designs for television provide the user with enough navigation options on-screen to keep any destination only a few clicks away while also managing to keep the screen from looking cluttered or confusing. In the design of the "Woodrow Wilson" enhanced DVD, H Design found unique solutions that kept the subnavigation menus clear, elegant, and on-screen. ▶

[Challenge] KCET, Los Angeles's PBS affiliate, brought in H Design to develop an enhanced experience for a three-hour documentary on the life of Woodrow Wilson as part of WGBH's *American Experience* series. The original plan was to create an interactive single-screen experience using television set-top boxes, and a prototype was created early in the process to win funding for the project. A Web site containing more detailed information than the documentary was also planned. ▶

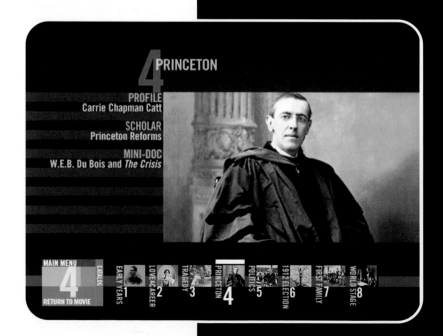

(LEFT) **This section of the program highlights Wilson's years at Princeton University. The innovative menu system lets the user navigate through the enhanced area of more detailed content while the individual segments of the program are highlighted in a linear menu at the bottom of the screen. Along with the segment headers, the menu presents thumbnail photographs to permit simple, visual navigation. The section currently in use is highlighted with a bar graphic and scaled numeral.**

[Solution] Based on the strength of the prototype, a decision was made to move the enhanced experience to a DVD. Viewers can either watch the complete and unenhanced documentary or watch a version that has simple graphic indicators that detail additional information. Viewers can pause the documentary and view enhanced "minidocumentaries," comments from the filmmaker, photo galleries, and biographies of key figures in the presentation. A time line shown in the enhanced area aids in navigating through the history of the story.

The simple, elegant design of the interface allows viewers to move through the documentary and explore the content in a number of ways. The project itself revealed to the designers a variety of new ways to organize secondary-viewing experiences. H Design's "Woodrow Wilson" production showcases the firm's bold use of navigational elements for a television-based product and shows how a single TV program can be a springboard for new ways to explore and experience stories and content. **]**

Dale Herigstad > **Creative Director**
Robert H. Sanborn > **Executive Producer**
Mickey Worsnup > **Producer**
Brad Bartlett, Ruben Espinoza > **Designers**

(ABOVE) **This screen shows off a creative solution to the difficult task of allowing four menus to remain on-screen simultaneously, which could have been a mess if not designed well. In this example, the inventive use of perpendicular menus makes it easy to distinguish among the menus and submenus. Because the video production is an important feature of the product, the design had to include the time-line menu that refers to the video at the bottom of all the screens.**

(RIGHT) **The companion Web site reflects the same branding elements as the DVD production. By incorporating the look and navigational design of the DVD, the two elements work together seamlessly.**

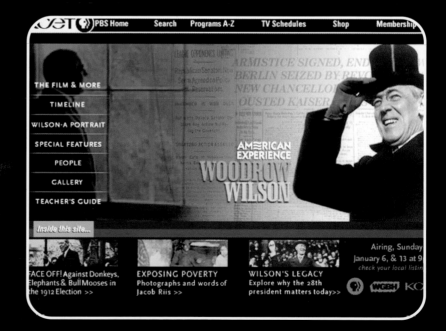

One of the biggest challenges facing designers of iTV is finding a framework for interactive navigation that works in the new environment. TV viewers are used to "channel surfing" across a linear plane of options, and some routinely use an electronic programming guide to jump to channels. But as the role of the television evolves to include myriad features, programming, and online functions, the complexities of navigating with a remote-control device multiply. Complex menu hierarchies are too cumbersome for television because users are in the "lean back" mode and prefer not to have to squint to read menus or think too hard about where they are.

The advanced, feature-rich television of the future will require navigation systems that are organic to the medium and can be instinctually navigated in the point-and-click environment. ▶

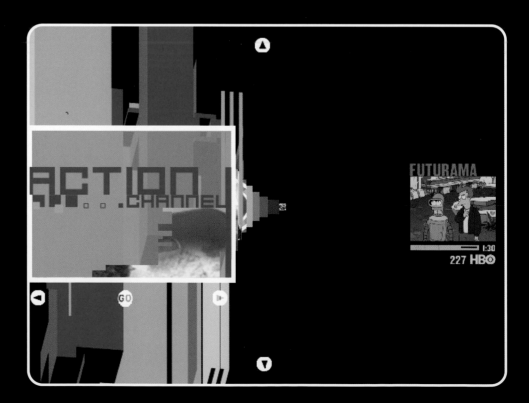

(RIGHT) **An identifier for a channel of programming called the Action Channel uses the directional arrows at the top and bottom of the full screen and at the left and right below the inset image as the main navigation elements on the screen.**

[Challenge] Sony U.S. Research Laboratories brought in H Design to develop the extensive prototype for its new Surf Space system. The platform is based on the concept of dimensional "surfing" of TV shows, Web content, E-mail, network promotion, home network, and favorite channels integrated into one dynamic system that presents these options in a spatial manner. The challenge for the designers of the prototype was to build an environment that could accommodate the future of television, when users will be faced with thousands of content choices and linear channel surfing will be obsolete. ▶

CHAT
BROWSER www.consolidatedskateboard.com

Welcome to
Website.

of visitors:

FUTURAMA
1:32
133 *TNT*

WEB

EMAIL

(ABOVE) **The interface combines Internet tools such as chat, a browser, and E-mail on a "screen inside a screen" that's used to navigate Web content.**

(RIGHT) **The custom remote control unit the design team developed features the same bold, condensed type treatments as the television interface and includes buttons that correspond to some of the unique features of the television interface, such as dimensional surfing.**

Dale Herigstad > **Creative Director**
Robert H. Sanborn > **Executive Producer**
Lynn Luckoff > **Producer**
Robert Howell, Kemper Bates > **Designers**

[Solution] Navigation of the Sony Surf Space is a primarily visual and graphic experience, giving the user the impression of surfing left, right, up, down, forward, and backward in three-dimensional space. The technology that this environment was built on is called Blendo. Blendo allows for real-time compositing and layering of multiple video streams and graphics in a 3-D space. Designers using this technology are working inside of a "real" 3-D space, as opposed to a two-dimensional simulation of a 3-D space. In order to design for this environment, H Design worked with a 3-D animator and animation software to build and design the interface's graphics and animation.

A primary task was to define the main functional areas of navigation and assign directional values to them. The user is prompted with a formation of small arrows that contextually reorient themselves to indicate the directions in each screen. Because this is a true three-dimensional space, the user can navigate backward and forward on the z-axis as well as the typical up, down, left, and right. "Dimensional skinning," which shows images in all three dimensions, is used to create a unique environment for the system. ▶

(ABOVE) **Show titles and network branding break outside the program preview box, lending the image a dynamic feel.**

(RIGHT) **With 3-D** navigational capability, the user can select any program in the "stack" to see a thumbnail preview of the show. Beneath the thumbnail image are a download-progress bar, the channel number, and the network's logo.

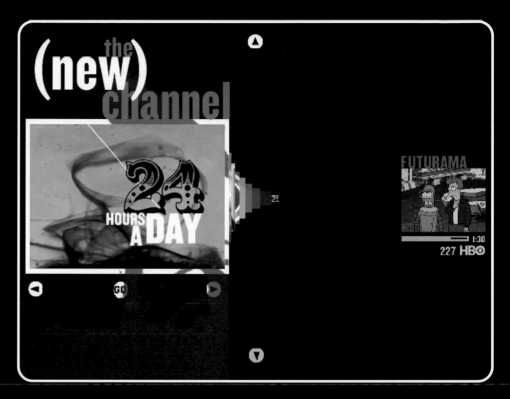

(LEFT) **Up to four** programs can be previewed on-screen simultaneously. In the bottom-center selection, a category identifier announces a submenu of game shows.

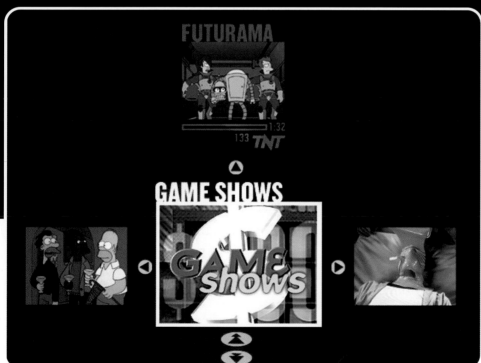

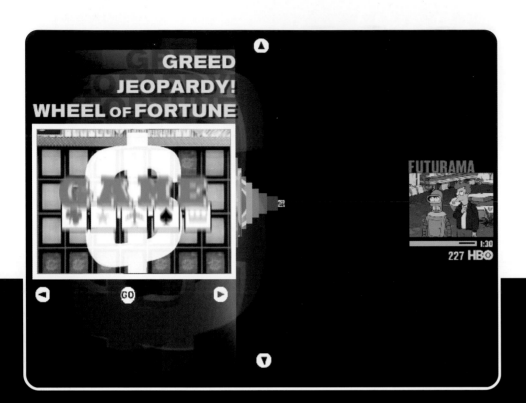

(ABOVE) **After selecting the game-show category, a list of the program choices appears.**

(RIGHT) **The system presents a "cognitive branching strip" it compiled in a manner similar to the way humans make mental connections between things—by associating the program being watched with others based on alternative parameters, such as having a common actor, creator, director, location, or production year.**

MALCOLM in the MIDDLE

FRANKIE MUNIZ ,
JANE KACZMAREK,
BRYAN CRANSTON 1999

COMEDY, Malcolm and his brother Dewy get their bikes stolen by bullies. They enter a battle of the bands to raise money for new bikes. Malcolm must keep his mother from finding out the bikes have been stolen. Dewy gets a huge record contract.

INFO 1:32 133 A&E

SUNDAY 8:36PM 9-03-00

FUTURAMA 1:32
133 TNT

(ABOVE) After selecting a program, the user can preview the episode's synopsis along with other relevant information.

In the central surfing area, content is organized in vertical strips by genre and other parameters. "Tribal strips," as the design team refers to them, can contain collections of shows or channels that a friend sends via E-mail in the Web application of the system, for example. "Cognitive branching strips," which the system builds based on the program being viewed, organize related shows. These strips are compiled in much the same way that humans form mental associations between topics, and are organized by different parameters, such as an actor, creator, director, location, or production year the programs all share.

To the left of the central surfing area is a section devoted to scrollable promotional windows that allow networks and other content providers to advertise their offerings in a rich-media environment. This area is very useful to content providers, because viewers are entertained as they navigate through branded channels to explore "what's on TV." These promo windows require minimal promotion and branding and can be surfed quickly. The user simply moves through the windows and, when enticed, zooms into that space and is "immersed" in that network's experience. Once inside, dynamically presented imagery leads the user forward into a space completely controlled by the content provider to deliver customized, branded experiences.

Another feature of the Surf Space system is a customizable TV listings guide that digests the five-hundred-channel universe into a list of selections based on the unique preferences of the user.

H Design also designed and delivered a remote control especially for this set of unique capabilities and features. ⊃

One issue that iTV designers struggle with is trying to strike a balance between the programming and the interactive features—which element should they make the on-screen hero? Enhancements often take a quiet, backseat role, but in some instances, the program has been spoiled by overly intrusive interface elements. One interesting solution to this dilemma is to allow users to customize their screens so they get the degree of interactivity they want. ▶

(LEFT) The main menu screen was designed with a user-friendly set of icons and a secondary menu system that incorporates bold background colors to keep the two separate. The muted colors and soft imagery in the background bring the interface elements forward, allowing the featured content window to stand out.

Ken Papagan, iXL > **Project Lead**
Dale Herigstad > **Designer and Creative Director**

[**Challenge**] PBS was interested in exploring ways that original programming could be designed to integrate the opportunities enhanced television (ETV) offers. ETV is a type of interactive television that combines television programming with Weblike elements and enhancements. Sometimes those enhancements are simple text features overlayed on the program. In this case, PBS wanted to build interaction into the show from the ground up. ▶

(TOP RIGHT) **For a show entitled *HealthWeek*, users can choose to also see interviews and the results of polls on topics related to the show.**

(BOTTOM RIGHT) **A representation of the enhanced content coming up next appears at the left side of the screen, and an information bar for services tops the page. This image is for PBS, and the "Local" and "National" markers at the bottom of the screen are bread crumbs dropped to lead viewers to both the local and national program enhancements.**

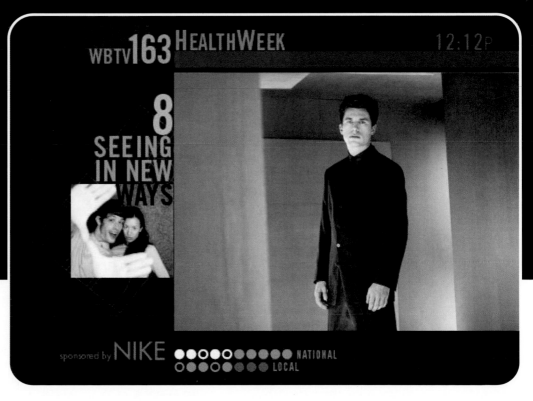

[**Solution**] H Design teamed up with the Los Angeles office of iXL, an international Internet solutions company, to produce the ETV platform prototype called More TV. Instead of giving the interactive features a backseat role, the designers boldly integrated them with the content. With interactivity in a more central role, the interface elements became a vital component of the experience's entertainment value. The platform allows users to choose the level and number of enhancements they want. The user can simply watch a full screen of video, or add various layers of enhancements by clicking the MORE button so a smaller video image and the interactive content share the screen. Starting from a main menu screen that feels like a combination of Web portal and programming guide, the user can access such features as E-mail, news tickers, and interactive programming.]

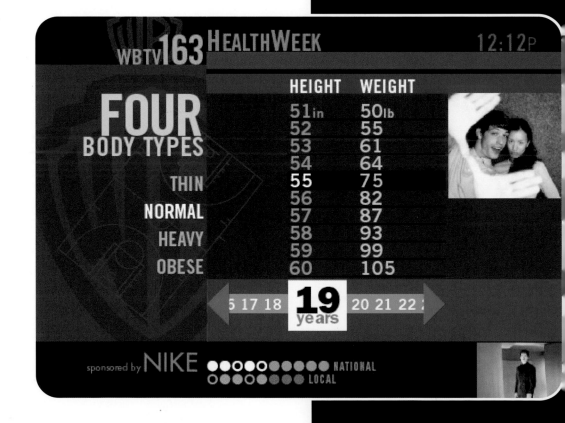

[RIGHT AND BELOW]
These screens are from a prototype of an ETV program focusing on literature from the Old South. The prototype lets you navigate to deeper levels of related information—from the music of the Old South one can explore the roots of blues, or of the geography of the region.

A COMMUNITY OF PRACTICE

By Anna Marie Piersimoni

The AFI Enhanced TV Workshop Synopsis

The installed base of in-home digital entertainment is growing, and viewers are demanding great programming to take advantage of the interactive features and enhancements they now have at their disposal. Whatever form "digital television" eventually takes, AFI believes that the creative community is the single most indispensable component to its success.

The AFI TV Workshop, the most prestigious enhanced TV R&D environment in existence, was designed to address this and has set the foundation for a growing community of enhanced TV and convergent media professionals. This workshop for television professionals is specifically designed to give television writers, producers, and directors an opportunity to explore and develop the medium of "enhanced television" through the creation of experimental prototypes based on their own broadcast properties. Now in its fifth year of operation, It is a hands-

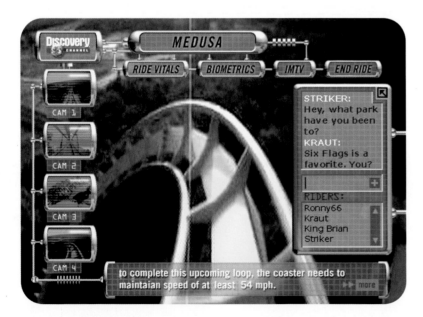

on production workshop funded by a unique combination of public and private sectors companies, including the Corporation for Public Broadcasting, Microsoft TV and Windows Media Division, Open TV, AT&T Digital Media Center, Liberate Technologies, and Interland, Inc. It is further supported with the *pro bono* services and skills of over a hundred leaders in digital and interactive technology and design.

Each year, approximately eight television professionals are selected by jury of industry experts to participate in the program. They must be seasoned professionals with a TV show on the air or with an air commitment. The workshop is based on a tried and true customized "apprenticeship" curriculum that the American Film Institute has developed over a long history of nurturing professional development.

The workshop begins with an extraordinary and ▶

much-anticipated experience within the professional community: a three-day orientation event featuring state-of-the-art examples of interactive media from around the world. The prototypes created in the workshop are presented at another public event a few months later and are also shown to influential leaders at the television networks, before AFI's prestigious Board of Trustees, and in a host of public venues. Previous participants in the Workshop include producers from *CNN Headline News*, HBO's *Arli$$*, Comedy Central's *The Daily Show With Jon Stewart*, *Blind Date*, E! Entertainment's *Talk Soup*, PBS' original drama, *American Family*, Discovery Channel, and Animal Planet, as well as top producers of several acclaimed PBS documentaries, such as *The New Americans*, *Accordion Dreams*, *The Roman Empire*, and *People Like Us: Social Class in America*.

The production phase occurs in the months between these two signature events and launches as a panel of technology and design experts are assembled into prototype production teams to guide and work with the producers on each jury-selected project, with AFI "executive producing" the process. During this phase, the producers not only learn about various platforms, tools, and technologies but how to master the creative, conceptual, production and technical challenges in migrating their traditional linear, broadcast properties to this new convergent medium. The focus on hands-on production of prototypes allows creative professionals and technologists to experiment together with the actual crafting of this new form of television. There is particular attention paid to visual design as well as functional design, with an emphasis on maintaining and expressing the "look and feel" of the program as well as the story content.

In addition to the individual professional development opportunity, this industry-wide collaborative effort has raised awareness of interactive TV with a direct impact on thousands of influencers in both the TV and technology communities. By successfully navigating platform wars and involving name-brand TV producers and distributors in hands-on production, this program has created a movement to bring credibility to the medium of "enhanced TV." And, the creation of innovative prototypes, shown widely throughout the industry, has served to stimulate debate and involvement and, as such, has built a "community of practice" at the highest level.

The impact of the digital revolution continues to offer challenges and opportunities to both for-profit and not-for-profit organizations in the entertainment community. AFI is no exception. AFI programs teach and celebrate an art form that is created and delivered through technologies. As the moving image art form has evolved from cinema to television, video, cable, and now to new media, so too has AFI sought to evolve its programs and professional support to reflect the changes in technology. ⌐

AGENCY.COM

It is difficult at the moment for filmmakers, producers, and content designers
to communicate some of their next-generation ideas for telling stories and entertaining view-
ers. Much of current iTV discussion revolves around the technologies and the limitations
instead of the actual approach, the ideas, or the narrative. The American Film Institute (AFI)
Enhanced Television Workshop challenges teams to work together to create prototypes that
move beyond the current limitations of technology and focus instead on the possibilities of
what's to come. ▶

A virtual thrill ride

Client > Discovery Networks **Developer >** AGENCY.COM **Platform >** iTV **Project Title >** *Extreme Rides*

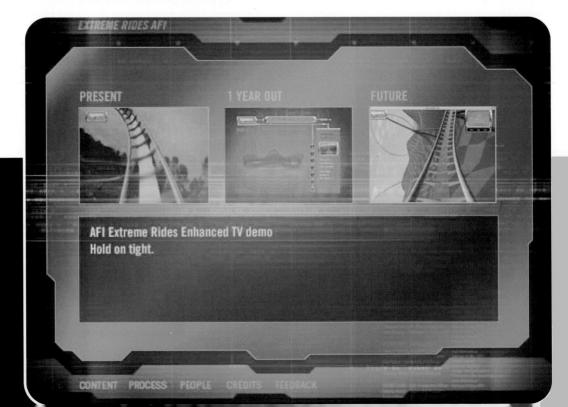

(RIGHT) **Designed
specifically for the AFI
presentation, this main
screen permits the user to
select among the three
prototypes, one for the
present, one for one year
out, and one for the future.**

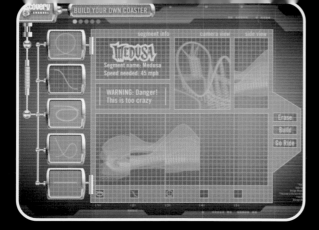

navigable wire-frame models
of roller coasters like this
one, called Medusa.

(BELOW) **On the main
selection screen, users can
choose among different
roller coasters and then
call up a wire-frame model
of the ride and the ride's
"vital statistics."**

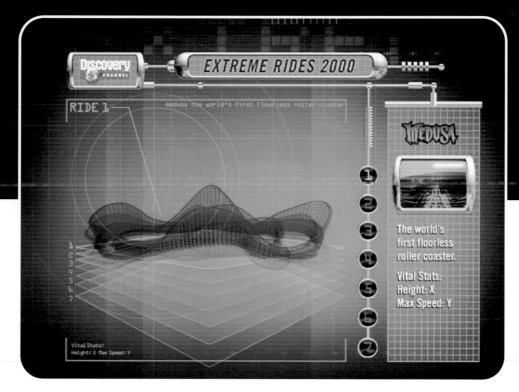

[**Challenge**] As part of the AFI Enhanced Television Workshop, AGENCY.COM was challenged as part of a team approach to develop ETV interaction for the Discovery Channel's *Extreme Rides* show. *Extreme Rides* is a popular prime-time series that features the design, engineering, and industry of roller coasters, as well as the culture surrounding them. With great visuals, a library of content to work with, a rich history, and a first-person perspective on the subject matter, the program offered many opportunities for creating an enhanced version that would take the user on a virtual ride.

The challenge was to find ways to add value to the existing show and help viewers imagine what it's like to design and build the ultimate extreme ride. In addition, AGENCY.COM needed to address the concerns and needs of the content producers of the show and the distributors, who were looking for ways to hold on to the show's captive audience even after the program was over. ▶

AGENCY.COM Interactive Television

[Solution] *Extreme Rides* provides the audience with multiple levels of interactivity and content designed around the program. The demo delivered features both synchronous and asynchronous to the show's broadcast.

According to AGENCY.COM creative director Dan Sellars, the brainstorming at the beginning of the project was one of the most exciting parts of the process. "It was a great opportunity to work alongside the Discovery Channel producers," he says. "We wanted to embrace their ideas and, at the same time, keep it rooted in the reality of what was doable, and what would make for a compelling user experience." This focus on the user experience also helped the group think beyond an emphasis on technology and concepts that previous AFI groups had used.

By avoiding too much specific detail at this early stage of the process, the team was able to focus on describing "buckets" of ideas that grew out of several brainstorming sessions. These buckets were used to separate ideas into synchronous content, nonsynchronous content, and broadband groups. The synchronous bucket contained enhancements to be added that related to the broadcast itself, in real time. The nonsynchronous, or postbroadcast, bucket ▶

(BELOW) **One feature of the interface for the virtual ride lets the user select among four camera angles by clicking on the on-screen prompt.**

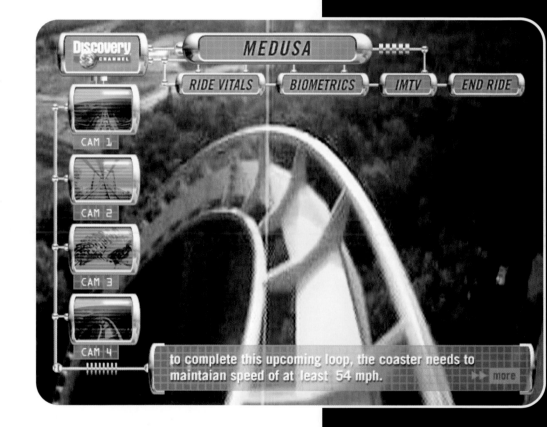

(TOP RIGHT) The ride "vitals" dynamically display detailed information like speed, height, g-force, and remaining ride time, changing with every twist, turn, and drop.

(MIDDLE RIGHT) Users activate the interactive features of the program by clicking on the channel ID logo.

(BELOW LEFT) Biometrics became a playful part of the enhancements, with data such as heart rate, scream volume, and the puke-o-meter represented graphically.

(BELOW RIGHT) The user can (in theory, anyway) chat with other users while experiencing the virtual ride simulation.

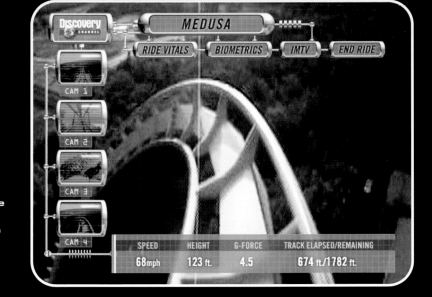

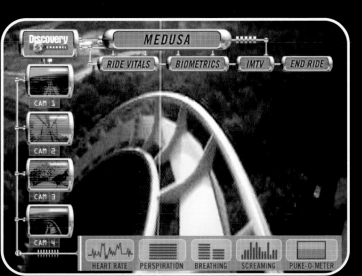

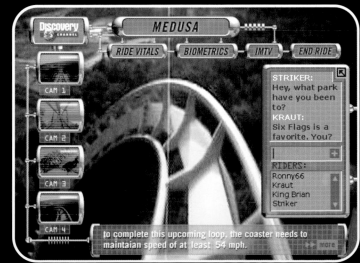

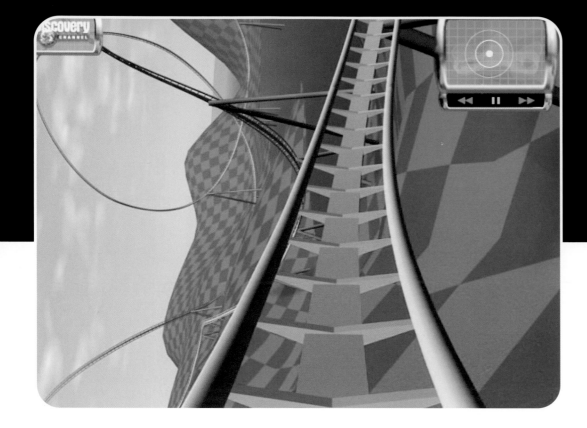

(LEFT) **In the "build-your-own-coaster" feature, roller coaster fans select segments of other coasters to make their own thrill rides. Then, the selections are compiled into a new QuickTime movie that lets them experience the virtual thrill of the dips, loops, and turns.**

included ideas about a form of related content that could be downloaded to a device similar to TiVo, which is a personal video recorder that can record and download TV content. Then there was the broadband bucket, which was for ideas that seemed better suited to a PC with a broadband connection than to iTV in the near future. After sorting the ideas, they designed and built three miniprototypes using concepts from these buckets, one for each method of delivery.

The designers came up with ways to let viewers leave the broadcast and ride any roller coaster of their choosing, change camera angles, and even chat with fellow riders and roller coaster enthusiasts. They also enabled users to compete in trivia contests, view behind-the-scenes interviews, and buy *Extreme Rides* merchandise. But the ultimate part of the ETV concept was a feature that let users build and "ride" their own and others' 3-D coasters, and then post them to a Web community for instant feedback via broadband.

Sellars says that one of the biggest challenges was keeping the prototype small enough in scope, yet visionary enough to get people excited and enthused. "It's a challenge gauging when you've reached the end, so I always try to visualize the finished prototype with storyboards and drawings to use as the benchmark to work toward." ▶

The project also demanded tightly coordinating sound designers, 3-D designers, and video editors with the core visual design team, who worked very closely with the show's creators. This team was spread across the U.S., so the project extranet became a crucial communication tool.

Sellars likens the project to a "rapid application prototype," a process that exists in industrial design as a way of evolving the thinking or concept in product design. It's about moving quickly through ideas while ensuring that you never lose sight of the product and the users until it's finally deployed. "It demands that you forgive the roughness. You're saying, 'We have these creative constraints, but let's evolve the creative thinking so that we can tangibly build around mock-ups and a set of typical user scenarios,'" he says. "This user-centered design philosophy helps to marry what you think is the right solution to what is the reality of it when you put it in front of users. You have to always strive to remove the complexity and ensure that it's intuitive. It's a great challenge striving for an elegant solution that users find both compelling and pleasurable to use."

The project was extremely well received by iTV industry leaders, the producers of the show, and Discovery Networks.

In the end, the *Extreme Rides* enhanced version gave the viewer a richer experience by giving him or her a chance to control and participate in the experience, thereby gaining a deeper insight into and experience of the subject matter. ⊐

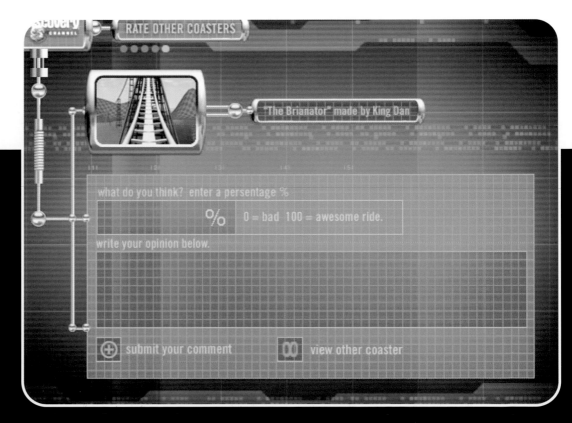

(RIGHT) Users can rate each other's rides and add comments that are submitted to the community Web site.

The features of interactive television programs are limited by the reality of the available technology. While many of the features of today's platforms allow for the addition of interactive materials to their existing linear content, the next generation of interactive programs is being organically conceived with audience interaction as the focus. These concepts challenge producers, engineers, designers, and programmers to work together to solve complex creative and technological challenges. Most of this work takes place behind the scenes, out of the view of the end user. Such was the case with the creation of *ROFL*, a Danish television concept that pushed the limits of interactivity and live television. ▶

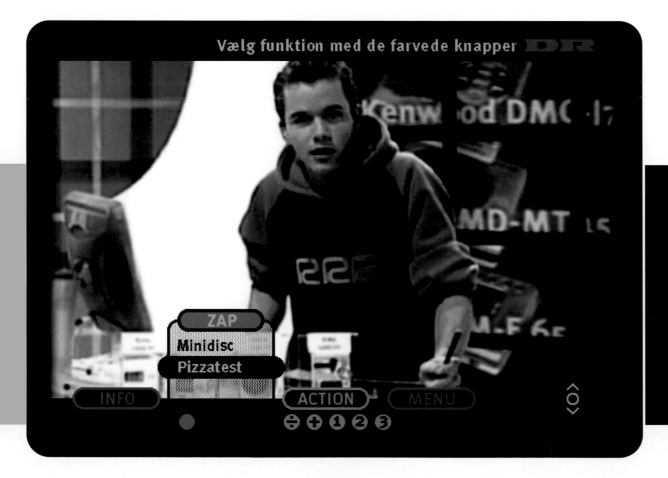

(LEFT) **The on-screen interface displays content not available to non-iTV viewers. Users access the interactive features with their remote controls. The on-screen menus mimic the look, feel, and color scheme of the remote control.**

[**Challenge**] *ROFL*, which roughly translates into "value for pocket money" is a live iTV show broadcast by the Danish Broadcasting Corporation (DBC) on digital TV using both the cable platform (TeleDanmark) and the satellite platform (Viasat). *ROFL* has an "infotainment" (part information, part entertainment) format that straddles the lines between consumer education, entertainment, and marketing for its audience of savvy twelve- to sixteen-year-olds. Many segments include product tests, and the show has elements of investigative journalism. The reporting on *ROFL* is serious and stories are thoroughly researched, but the tone used to present the findings is unpretentious and fun. There is extensive use of humor, and the presenter's sharp, personal style shines as he guides the viewer safely through the many alluring offers of products targeted at kids.

The show aims to make viewers smart, critical, and competent consumers, and does so in an entertaining way. An ongoing interactive quiz connects the viewers at home and drives the interaction throughout the show.

Because *ROFL* was among the first live iTV shows, AGENCY.COM took up the challenge of creating both the interactive production and the broadcast from the ground up. ▶

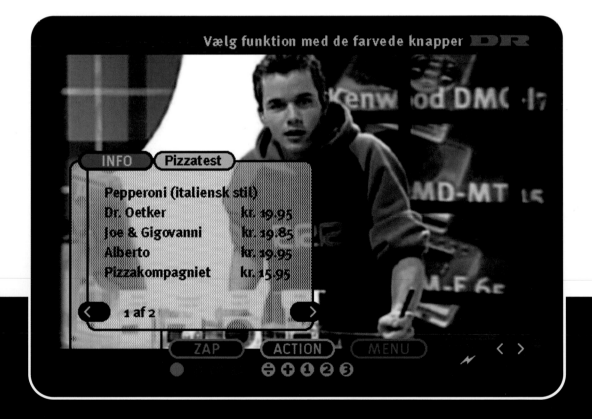

(ABOVE) **The ZAP button allows users to change the camera angle on a subject by choosing one of the four green dots. The ACTION menu is where viewers can access features such as polling and multiple-choice quizzes.**

[Solution] The AGENCY.COM iTV team had to devise and build the entire back-end system to fit the highly specialized production environment of a live TV show. In addition, the technology they used had to allow *ROFL* to be broadcast across two very different networks, cable and satellite. The team had to be certain that the system's every detail would ensure stability for the live television context. In addition, mechanisms to accommodate live updates and real-time changes had to be created.

Viewers of *ROFL* have four main interactive functions at their fingertips during a live broadcast. They use their remotes to:

1. Choose between different video streams:

 a) Choose between the production feed and an alternative feed that follows a story as it evolves during an episode (x-cam)

 b) Choose between three different journalistic angles to a particular story

2. Participate in a quiz for a chance to win a $1,500 cash prize

3. Select additional information on topics the show raised

4. Participate in story-related surveys and polls ▶

(BELOW) **The audience can play along by answering multiple-choice quiz questions to compete for a prize.**

www.dr.dk/ROFL **Vælg funktion med de farvede knapper** DR

INFO ZAP ACTION MENU

(ABOVE) **The interface uses minimal screen real estate, ensuring that the focus remains on the show.**

The viewer accesses these functions through an interface created in a graphics layer on top of the video stream. To navigate in the menus, the viewer uses the four colored buttons, the arrow keys, and the OK button. The interactive functions are designed to have a radical impact on the way the show is seen and felt—and to make viewers feel that they have a say about the issues.

ROFL was launched January 23, 2001, on Viasat's and TeleDanmark's platforms. Twenty episodes were scheduled to be broadcast during prime time on Tuesdays to the steadily growing number of Danish digital subscribers. The DBC and AGENCY.COM were honored with the prestigious EMMA (European Multimedia Award) for Best Interactive TV Application in recognition of their exceptional work in digital media. In awarding the EMMA, the judges said that *ROFL* "is an excellent example of a truly interactive TV experience which combines context, design interaction, and synchronization to create a live, dynamic, and easy-to-use format. It is refreshing to see a treatment that combines linear TV format with interactive components."]

ARTiFACT

Many concepts and designs for interactive television offer value-added features of information, gaming, or commerce. But it is rare to find examples of iTV that rise to the level of art or stand on their own as dramatic entertainment.

With the creation of an interactive journal for the PBS series *American Family*, ARTiFACT delivered a two-screen episodic extension that is an inspiring example of the possibilities for iTV when its design is in the hands of talented artists who know how to tell stories. ▶

Journey through a journal

Client > El Norte Productions in conjunction with KCET and PBS

Developer > ARTiFACT **Platform** > iTV/Two-Screen **Project Title** > *American Family—Cisco's Journal*

 PBS The 'PBS' logo is a trademark of the Public Broadcasting Service and is used with permission, www.pbs.org

(RIGHT) The Gonzalez family tree on the left-hand side was executed as a linoleum print by one of the ARTiFACT designers. As the viewer's cursor passes over a name on the tree, the character's image is highlighted in the collage on the right-hand side, as is a one-line description of that family member.

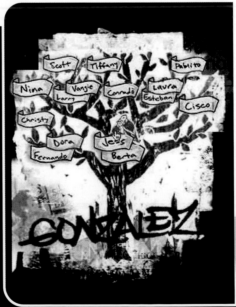

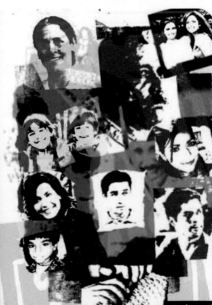

ARTiFACT [+] iTV

Steve Armstrong > **Senior Creative Director**
Steve Tobenkin > **Senior Producer, Project Lead**
Michael Waters > **President (ARTiFACT, Inc.), Producer**
Corinne Nakamura > **Lead Designer**
Luca Giannettoni > **Designer**
Dean Sacramone > **Lead Programmer**
Mike Armstrong > **Programmer**
Chris Carneal > **Design Associate**
Paul Conner > **Video Optimization**
Dan Clougherty > **Video Editor**
Mike Benecke > **Video Editor**

EL NORTE PRODUCTIONS

Gregory Nava > **Executive Producer, Director/Writer**
Barbara Martinez-Jitner > **Supervising Producer, Director/Writer**

KCET LOS ANGELES

Jacqueline Kain > **Director of New Media**

PBS INTERACTIVE

Jennifer Sale > **Editor, Arts, Drama & Performance**
Cindy Johanson > **Senior Vice President**

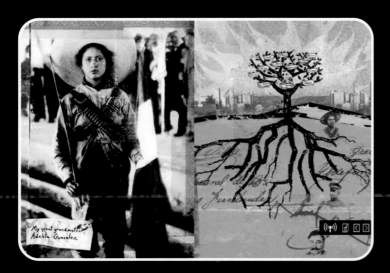

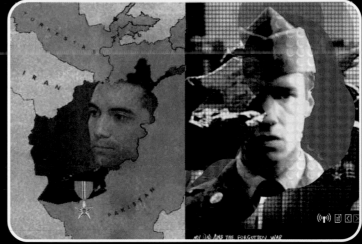

(TOP LEFT) **The family tree on the right extends its roots to represent the family's roots in Mexico. The woman on the left is Cisco's great-grandmother, Adelita. She is a somewhat mythical figure, La Soldera, a woman who fought in the Mexican Revolution.**

(TOP RIGHT) **In an episode that memorialized the victims of the September 11, 2001, terrorist attacks, the left side shows Cisco's father remembering his participation in the "Forgotten War" in Korea. The image fades over a map of North Korea and South Korea. The generations are linked together by the image of his son, a doctor who has enlisted to join the fight in Afghanistan, on the right side of the screen.**

(BOTTOM RIGHT) **This diptych is Cisco's memorial to his deceased mother. Because his mother was always sewing, the image includes the sewing machine on the right. When the cursor rolls over the sewing machine, the user hears the whirring sound of sewing that reminds Cisco of his mother. On the left are traditional offering candles, which the user can ignite in a memorial to Cisco's mother.**

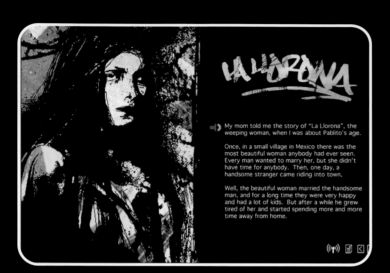

LA LLORONA

My mom told me the story of "La Llorona", the weeping woman, when I was about Pablito's age.

Once, in a small village in Mexico there was the most beautiful woman anybody had ever seen. Every man wanted to marry her, but she didn't have time for anybody. Then, one day, a handsome stranger came riding into town.

Well, the beautiful woman married the handsome man, and for a long time they were very happy and had a lot of kids. But after a while he grew tired of her and started spending more and more time away from home.

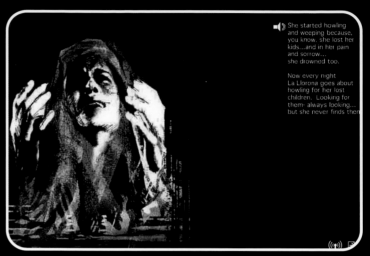

She started howling and weeping because, you know, she lost her kids...and in her pain and sorrow... she drowned too.

Now every night La Llorona goes about howling for her lost children. Looking for them- always looking... but she never finds them.

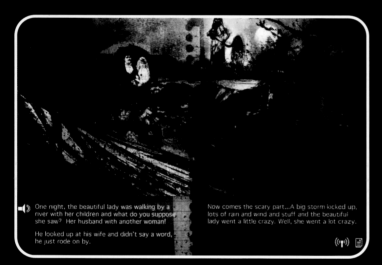

One night, the beautiful lady was walking by a river with her children and what do you suppose she saw? Her husband with another woman!

He looked up at his wife and didn't say a word, he just rode on by.

Now comes the scary part...A big storm kicked up, lots of rain and wind and stuff and the beautiful lady went a little crazy. Well, she went a lot crazy.

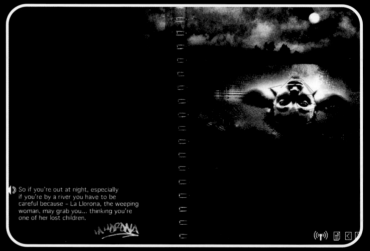

So if you're out at night, especially if you're by a river you have to be careful because – La Llorona, the weeping woman, may grab you... thinking you're one of her lost children.

(THIS PAGE) La Lorona is a famous Mexican myth about a grief-stricken woman who drowns her children and then herself after seeing her husband with another woman. The legend says that she is forever roaming the Earth, looking for her lost children. The story permeates Mexican culture, and Cisco is reflecting on it because of a situation involving motherhood on the show. The illustrations are photographs that were digitized and drawn over. The story is accompanied by audio taken from the show of Cisco reading the legend.

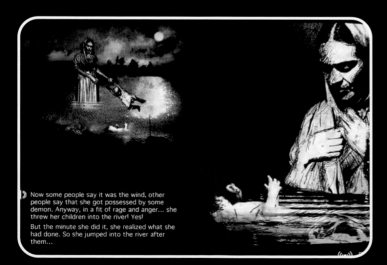

Now some people say it was the wind, other people say that she got possessed by some demon. Anyway, in a fit of rage and anger... she threw her children into the river! Yes!

But the minute she did it, she realized what she had done. So she jumped into the river after them...

[**Challenge**] *American Family* is the first drama series on broadcast television to feature a Latino cast, as well as PBS's first original, prime-time episodic drama in decades. The show chronicles the daily struggles and triumphs of an American family living in Los Angeles.

At an AFI Enhanced Television Workshop event, Barbara Martinez-Jitner, writer, director, and supervising producer of the series, approached Steve Armstrong, president and creative director of ARTiFACT, with the idea to extend the character development of the show's nineteen-year-old main character, Cisco, by bringing his journal to life via interactive television. Ideally, the journal would be an extension of the show and reflect what was currently happening in the series and in the life and mind of the character.

The journal was written into the show's scripts, and Cisco was seen at his computer working on it as episodes unfolded. On the show, Cisco appears to be a young man who goes with the flow. By interacting with the journal, however, the viewers are allowed to gain a deeper understanding of this young man and how he feels about what's going on in the world around him, in his family, and in his life. ▶

(ABOVE) **In this episode, Cisco finds himself in Tijuana shooting a music video during *Los Dias de los Muertos*, or Days of the Dead, the Mexican Halloween. Click on the pile of bones to make them "rise from the dead" and dance to the music of the band whose video he is shooting. The left side shows Cisco's calendar, highlighting the shoot. The finished music video is available online in an area of the journal where Cisco posts video clips.**

[Solution] The goal for ARTiFACT's team of creatives was to depict the essence of the Cisco character on the show by speaking with one consistent voice as Cisco grows during the course of the series.

The journal that is depicted is a visual, as opposed to a literary, journal. Cisco is an untrained but very talented multimedia artist who expresses himself by creating a very personal multimedia journal. "Exploring the journal really helps to make viewers feel like the character lives and breathes," says Armstrong. To enhance the sense of his journaling in "real time," each entry goes online when the episode is first aired on the East Coast.

Conceptually, the character is creating a personal multimedia journal, so it was intentionally designed not to feel like a public Web site. With a Web site, the idea is to make things behave consistently and to provide the user with clear navigation and direction. But in this case, the idea was about discovery and exploration. The navigation turns the pages in a very literal way, as opposed to providing the user with a menu of options.

"We wanted exploration, we wanted discovery, we wanted people to have to touch the pages to go somewhere," Armstrong says. "It's a 'fourth wall' character issue, because the character doesn't know he's doing a show, and so he wouldn't worry about many of the issues professional Web designers must deal with." ▶

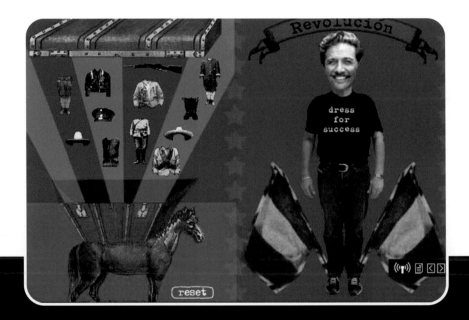

(THIS PAGE) **These screens feature an interactive "dress-up doll" in which the user can outfit Cisco's family members with uniforms handed down from ancestors who fought in the Mexican Revolution. These images were made from a combination of images from the show, illustrations, and additional photo research.**

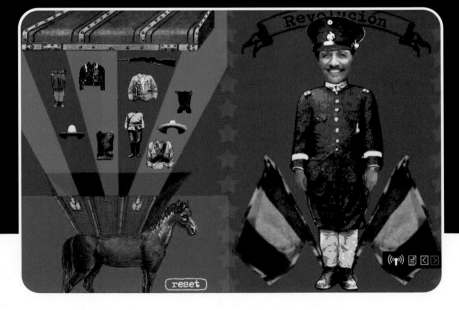

(TOP AND LEFT) **These diptychs show details of graffiti, juxtaposed with personal art, to illustrate how graffiti plays a big role in Cisco's life.**

(ABOVE RIGHT) **Cisco's brother Esteban is faced with a no-win situation as a fireman (represented by the right side of the screen), and he is torn between his commitments to his job and his girlfriend, a ballerina, whose character is represented on the left-hand screen. When you pass the cursor over that side, the music box opens and the ballerina dances; when the cursor is on the right side, which highlights Esteban's responsibilities, the dancer goes away and the music box closes. The cursor icon on this screen is a heart in flames, pierced by a sword and wrapped in barbed wire to represent Esteban's conflict between passion and duty.**

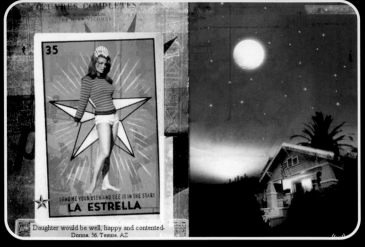

(BELOW) **A statement about Cisco's frustration over the prosecution of graffiti artists is followed on the left-hand side by an invitation to try graffiti for yourself. The next screen shows how the utility can be used to make original graffiti art with the spray can icon, which is pressure sensitive, just like a real spray can.**

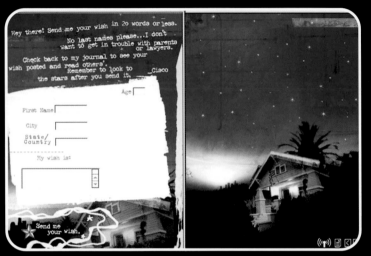

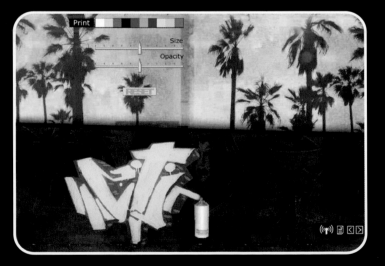

(ABOVE) **This episode was entitled "La Estrella," or "The Star," and featured Raquel Welch as Cisco's aunt, an aging former Hollywood star. On the right-hand side, the sky above the family house hosts sporadic celestial events, such as an Aztec god riding a comet, a moonrise, a shooting star, and other surprises. On the left-hand side is a picture of a younger Raquel Welch, representing Cisco's aunt when she was in her prime. These "wishes" that real visitors have sent in are posted below the picture of Cisco's aunt.**

A utility available from the left-hand panel lets users "wish upon a star," and asks only for their first name in order to ensure anonymity.

(BELOW) **Run, Esteban, Run is a dark game based on an episode in which Esteban finds himself in a terrible situation, with no pleasant outcome possible. The game allows the visitor to play out the various scenarios the character feels he is facing, and to feel the helplessness that sometimes develops in a no-win situation. The game is rendered in a retro Pac-Man style, which adds to the dark irony of the game.**

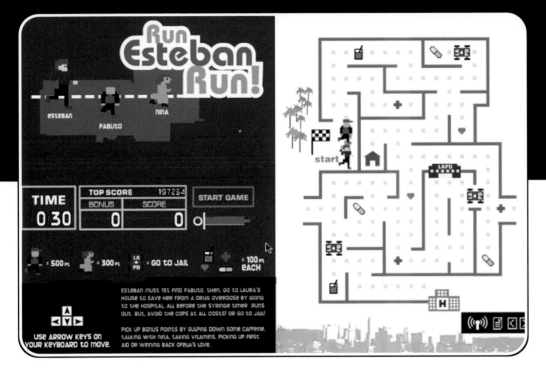

The journal design is centered on a vertically split screen reminiscent of a two-leaved hinged tablet called a diptych, a shape that's often used for Spanish folk and religious art. The adjacent images on the screen play off each other in a push-and-pull relationship that helps to subtly define some of the character's struggles.

"We really liked the idea that it took away from the typically horizontal composition and structure that is done on most television and computer screens," says Armstrong. "Secondly, it removed the limitations of one image always having to solve everything. In this case, we are dealing with two or more images that allow for a more complex interaction. And thirdly," he continues, "relative to this dense visual structure that we were interested in doing, it enabled us to create more complex visual compositions, which runs against traditional Web design aesthetics."

But this complexity created a big challenge for the designers and programmers. They worked hard to keep the page weights down so the pages would load quickly, but they wanted to have interesting visuals that did not look like a product designed for the Web. PBS has profiles of its target online users and has set page-weight limits and more flexible restrictions regarding the use of Flash and other plug-ins in order to accommodate the majority of users who have 56K telephone connections. The original images frequently would go through several iterations and resolution compromises to decrease page weights without sacrificing Cisco's artistic vision. ⊐

Client > Kartemquin Films **Developer** > ARTiFACT **Platform** > iTV/Two-Screen **Project Title** > *New Americans*

Sometimes the biggest ideas are the simplest. With an increasingly multicultural, multilingual population in the United States, adding streaming-audio language translation in sync with programming would be of great benefit to large populations of viewers. With the addition of these features to the programming for *New Americans*, ARTiFACT demonstrated to an AFI audience how interactive features can add real value for a wide range of viewers. ▶

(ABOVE) **A set-up screen beneath the image introduces viewers to the interactive features.**

ARTIFACT [+] ITV
Steve Armstrong > **Creative Director**
Peter Kagan > **Creative Director**
Michael Waters > **President (ARTiFACT, Inc.)**
Steve Tobenkin > **Senior Producer, Project Lead**
Scott Kline > **Technical Consultant**
Corinne Nakamura > **Lead Designer**
Luca Giannettoni > **Designer**

Gordon Quinn > **Executive Producer, Kartemquin Films**
Ken Papagan > **Delmar Media**

THE AMERICAN FILM INSTITUTE ENHANCED TV WORKSHOP, 2001
Marcia Zellers > **Director of Enhanced Television**
Erin Flood > **Production Manager, Enhanced Television**
Anna Marie Piersimoni > **Associate Director, New Media Ventures**

[Challenge] Louis Barbash, a producer for the Corporation for Public Broadcasting, had approached Gordon Quinn, one of the producers and founders of Kartemquin Films, about bringing a documentary series Kartemquin had been working on called *New Americans* to the AFI Enhanced Television Workshop as a subject for an iTV prototype. The show relates the experiences of individual immigrants in the U.S., before, during, and after coming to the country.

Quinn was interested, but initially skeptical (as artists often are) about the idea of anybody "messing with the story." The film company spent a lot of time on the dramatic pacing, the editing, and the feeling of the production, so Quinn's concern that adding interactivity could destroy the emotional tie between the viewer and the narrative was valid. ▶

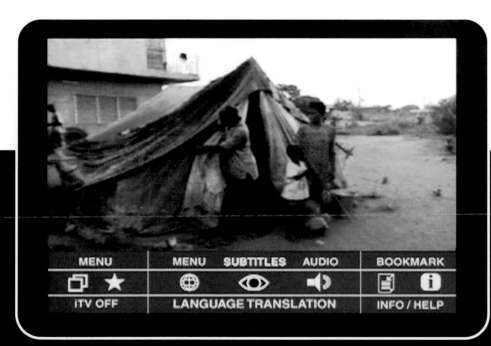

(TOP LEFT) **The menu system is built on a simple grid, and menu options are also displayed as universally recognized icons for viewers who don't read English.**

(BOTTOM LEFT) **A multi-language menu screen allows viewers to set up the audio in the language of their choice. The options to turn the enhanced features off or on or to change the screen layout are always available.**

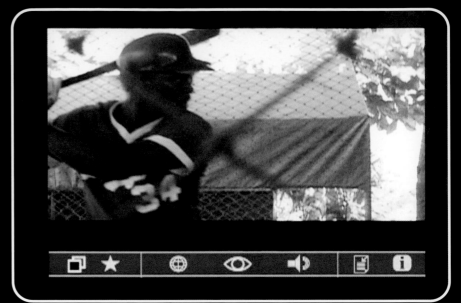

(BELOW AND RIGHT) **The subtitles on the screen can be turned off, leaving a purely visual navigation system. The menu system also works on a purely visual level that transcends language barriers.**

MENU MENU **SUBTÍTULOS** AUDIO MARCADOR

ITV APAGAR TRADUCCIONES INFO / AYUDA

ARTiFACT was one of the AFI program's mentors, and ARTiFACT president and creative director Steve Armstrong was particularly drawn to working with *New Americans* for a number of reasons. He liked the social statement that the program made and felt there was a strong need, especially after the terrorist attacks on September 11, 2001, to promote an understanding of the immigrant experience in the U.S. "This wasn't about giving people alternate endings to a story, or some cute game, this was about a real-life situation," notes Armstrong. After meeting Quinn and discussing their common understanding of the show's sensibility, they agreed to team up for the project. ▶

(LEFT) **The menu can be reduced to display only the yellow star, which is the icon that turns the interactive features on and off.**

(BELOW) **Turning on the bookmarking feature allows links relevant to the content to be flashed on-screen when they're available, and then the user can choose to save and store them in the Web browser.**

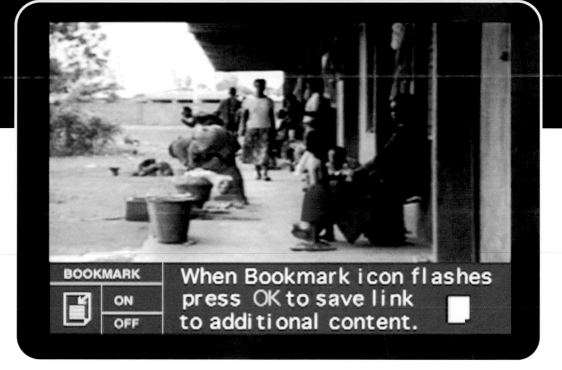

[**Solution**] The documentary series made use of a significant amount of subtitling, and Armstrong asked himself, "Wouldn't it be great if the text translations could be there for people, but they also could hear this in their own language?" He hit upon the simple yet innovative idea of using the Internet as a delivery vehicle for streaming multiple synchronous audio translations. Quinn agreed that the solution was perfect, so the team went ahead with the concept that the language options would be the core interactive feature of the show.

The idea was that users would log on to an icon-driven set-up page where they would select a specific language. Then, following instructions in the language of their choice, they would indicate what station was their local PBS affiliate and select a language for synchronous audio. When the episodes aired, users would return to a bookmarked page and, with the click of a single button, hear an in-sync audio translation for the program. ▶

While it technically is a "two-screen solution," users can run the audio from their computer into their TV or AV receiver. The computer becomes a component of the television system, and it appears that the audio is coming with the picture. One of the highlights of the solution, particularly in the opinion of the workshop's participants, is that it doesn't require any new technology. Making this work requires only things that are available today.

The team also produced a more enhanced single-screen version, which allows the viewer to choose the audio and text subtitling directly through the television with a remote control. The interactive features include an on-screen bar menu for setting up language choices. One thing that helped compositionally is that the show is shot in a wide-screen format, so the picture can be moved up on the screen, freeing up screen real estate below. Positioned horizontally ▶

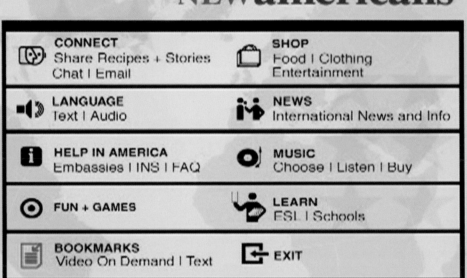

(ABOVE) **The New Americans enhanced site is also a community portal that lives outside of the show's broadcast. This menu system, too, is based on a system of icons, so first-time visitors who have not set it up for their language can easily identify their options.**

(RIGHT) **A visual system of archiving bookmarks allows users to quickly identify and access saved content.**

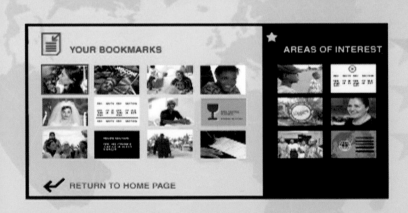

beneath the picture, the menu can be opened, expanded, reduced, or turned off altogether.

The single-screen version also includes a home portal on the television that allows immigrant communities to share community information and access government information and services. A video-on-demand feature means that relevant content not included in the episode's final cut can be accessed at will.

The feedback from seasoned veterans of the AFI workshop was that the project was one of the most seamlessly conceptual and visual examples that had come out of the program. "For us, that's a big compliment, because it means we solved a lot of things that we set out to do," says Armstrong. "It's not about the technology. It's about enhancing people's lives with easy-to-use, yet powerful applications." ⊃

This is a video clip about Palestinian cooking.

Length: 00:04:28

Press play > to start.

(LEFT AND ABOVE) **This VCR-like control menu is used to access and view additional video content that has been bookmarked and downloaded.**

BBC INTERACTIVE

The BBC has long been on the cutting edge of broadcasting. Content is king in the multichannel age, and no network takes more pride in the quality of its content than the BBC. It is no surprise, then, to see the BBC taking a leading role in the quest to add value to the viewing experience. In 2000, BBC Interactive, or BBCi, first added interactive services to its coverage of the country's premier sporting event, the Wimbledon tennis championship. ▶

An impressive serve

Client > BBC **Developer >** BBCi **Platform >** Digital Satellite **Project Title >** Wimbledon

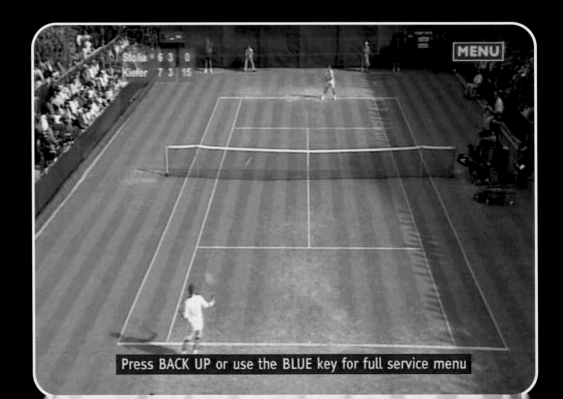

(RIGHT) **A prompt tells the user how to either navigate to previously viewed features or reach the main menu for a complete list of options.**

Press BACK UP or use the BLUE key for full service menu

Mike McDonald > **Interactive Television Designer**
Vlad Cohen > **Head of Design**

[Challenge] Wimbledon is an unusual sporting event in that its audience members include people from a wide cross section of ages and cultural backgrounds. For this reason, simplicity and ease of navigation were vitally important. It was essential that the concept of the interactive service be obvious from the outset and that the navigation feel generic and natural. ▶

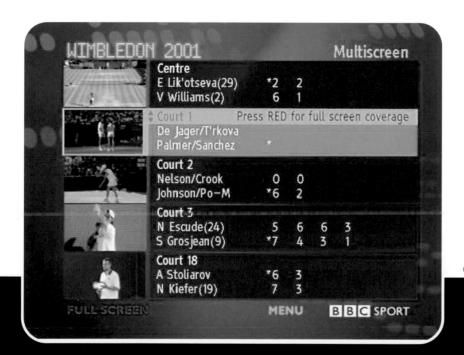

Courtesy of The All England Lawn Tennis Club

(TOP) **By choosing the multiscreen mode, viewers can watch up to five matches at a time. A match can be expanded to full-screen status by navigating within the match grid.**

(BOTTOM) **The selection box that drops down from the menu button lets the user choose to view the scores in other matches in progress, see results from finished matches, and watch multiple events in multiscreen mode.**

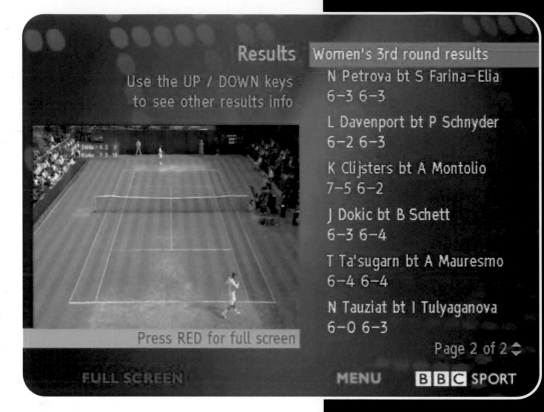

Results · Women's 3rd round results

Use the UP / DOWN keys
to see other results info

N Petrova bt S Farina–Elia
6–3 6–3

L Davenport bt P Schnyder
6–2 6–3

K Clijsters bt A Montolio
7–5 6–2

J Dokic bt B Schett
6–3 6–4

T Ta'sugarn bt A Mauresmo
6–4 6–4

N Tauziat bt I Tulyaganova
6–0 6–3

Press RED for full screen

Page 2 of 2

FULL SCREEN · MENU · BBC SPORT

[Solution] The Wimbledon interactive service provided viewers with access to not only the center court, but also to four additional live matches together with current scores and updated final results throughout the tournament. When viewers entered the interactive programming, they were presented with a "multiscreen" that offered the channel they were watching and a menu of four alternative matches and their respective scores. Using the UP and DOWN keys, the viewer could highlight the option of his or her choice and press the SELECT or red key to watch full-screen coverage. Throughout the service, the designers provided a pop-up menu offering access to the multiscreen, live scores, and all results. Scores and results were delivered in quarter-screen format, which allowed the viewer to browse without losing sight of his or her chosen match.

The digital satellite service has proven to be a great success in terms of viewing figures and user feedback. Over the two weeks of the 2001 tournament, 4.1 million unique view-

(ABOVE) **Choosing RESULTS on the main screen splits the screen between the scoreboard and the match in progress.**

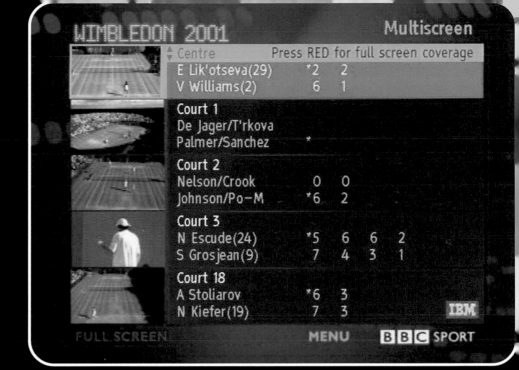

Multiscreen

Centre Press RED for full screen coverage

E Lik'otseva(29)	*2	2		
V Williams(2)	6	1		

Court 1
De Jager/T'rkova
Palmer/Sanchez *

Court 2

Nelson/Crook	0	0		
Johnson/Po—M	*6	2		

Court 3

N Escude(24)	*5	6	6	2
S Grosjean(9)	7	4	3	1

Court 18

A Stoliarov	*6	3		
N Kiefer(19)	7	3		

IBM

FULL SCREEN MENU BBC SPORT

(TOP) **Upon returning to the multiscreen menu, the viewer again sees the other matches in progress and can choose another one to watch in the full screen.**

(BOTTOM) **The program's interactive features, with the exception of the MENU button, can be hidden for normal viewing.**

Walking with Beasts, a major digital animation series produced for BBC Science, begins its tale 49 million years ago, nearly 15 million years after dinosaurs became extinct. The six episodes of the docudrama chronologically chart the rise of the mammals and the evolution of man as the *Jurassic Park*-style robotic models and digital animation take the viewer on a walk with beasts.

With a wealth of information to support the subject matter and a fascinating production process to divulge, the series presented an ideal opportunity for the BBC to produce for viewers of digital television one of the first truly interactive programs. ▶

The menu system is kept from intruding on the video content by placing it in a band across the bottom. Users can choose between minimal narration, (TOP RIGHT) and a more in-depth treatment of the content, (BOTTOM RIGHT).

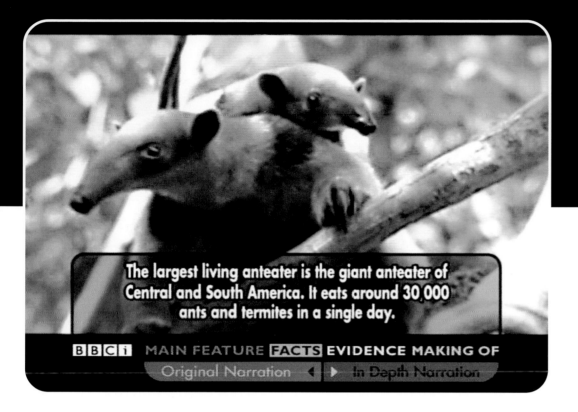

The largest living anteater is the giant anteater of Central and South America. It eats around 30,000 ants and termites in a single day.

BBCi MAIN FEATURE FACTS EVIDENCE MAKING OF
Original Narration ◀ ▶ In Depth Narration

(LEFT) **When a user chooses one of the main options, such as FACTS, the text appears in a screen that has a transparent background, but the opaque white type outlined with black is still very readable.**

[Challenge] The creation of BBCi's *Walking with Beasts* challenged the developers on a number of levels. The first was that the production required the designers to figure out what interactive components would be compelling within a linear narrative structure. Despite the scale of the project and the number of creative people involved, it was essential to keep the concept as a whole as simple as possible. The designers were also required to integrate the interactive designs with broadcast graphic designs and to provide design continuity across other platforms (like Web and cable TV). *Walking with Beasts* ultimately would be rolled out across five platforms. ▶

Katherine Hall > **Interactive Television Designer**
Paul Baguley > **Broadcast Designer**
Vlad Cohen > **Head of Design, Interactive Television**

[Solution] BBCi's *Walking with Beasts* aired on BBC One in Autumn 2001. A follow-up to the renowned BBC program *Walking with Dinosaurs*, it permitted 1.9 million digital satellite viewers, as well as uncounted digital terrestrial, Web, broadband, and cable television viewers across the U.K., to interact with the popular documentary program. The digital satellite service allowed viewers to customize their viewing experience by choosing from different audio and video components. They could choose a different narrator, activate pop-up translucent fact boxes, or even watch synchronized picture-in-picture clips to learn more about the scientific evidence or the making of the program. The interactive component was a coproduction of the BBC's New Media and Factual and Learning Departments. ▶

(BELOW) **The EVIDENCE feature breaks from the main content to a picture-in-picture. That way, users can visually compare the fossils shown in one picture with the animatronic re-creation of the dinosaur in the other.**

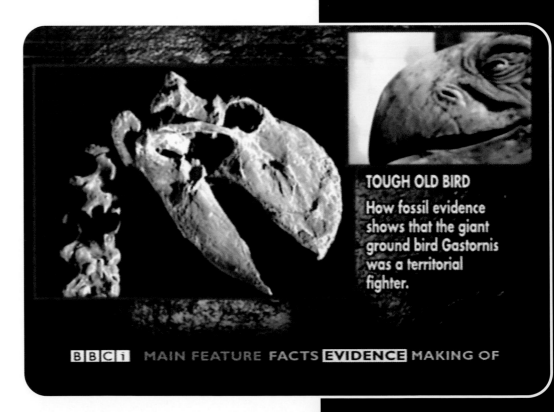

TOUGH OLD BIRD

How fossil evidence shows that the giant ground bird Gastornis was a territorial fighter.

BBCi MAIN FEATURE FACTS **EVIDENCE** MAKING OF

(BELOW TOP) **The same picture-in-picture feature used in the screen at left to compare fossil evidence with the animatronic creature is also employed to give users a glimpse into how the show's creators produced their realistic re-creations of dinosaurs.**

(BELOW BOTTOM) **The user can choose to turn off all the interactive features and menus to watch the program in the full-size screen.**

The designs were created to provide a stable and simple framework for the viewing experience. It was important to build on the look and feel of the original program by using earth-tone color schemes and animated backgrounds, such as a prehistoric rock texture. Type and layout were also used specifically to reinforce the BBC's iTV house style.

The program was a high-profile BBC launch, and therefore the project was a high-pressure, lengthy process in terms of liaison and consistency across platforms. *Walking with Beasts* was the first project of so large a size for the BBC at the time of the broadcast, and it paved the way for subsequent interactive productions. The project also proved what the designers suspected from the outset: Viewers want interactivity to enrich the viewing experience with very simple, high-quality features, not with elaborate distractions. ⊐

PREHISTORIC TWITCHER
How the animatronic team brought hopping insect-hunters to life in the forests of Java.

B B C i MAIN FEATURE FACTS EVIDENCE MAKING OF

A winning goal

Client > BBC **Developer >** BBCi **Platform >** Digital Satellite
Project Title > Digital Satellite Football Association Cup

For true sports fanatics, there is no such thing as "too much information." But even average fans love having access to live statistics, radio commentary, and alternative camera views during a televised sports event like the Football Association Cup, and the BBC's interactive service offered to customers of any digital service just those added-value services in tandem with the live match coverage. ▶

[Challenge] Football is an enormously successful form of entertainment worldwide, and in the U.K., the BBC has a reputation for delivering the highest-quality coverage. The challenge was to create an experience that genuinely enhanced the event for the viewers. In order to make this possible, it was vital that navigation be simple and fast, requiring minimal concentration from the viewer and offering real incentives to interact. ▶

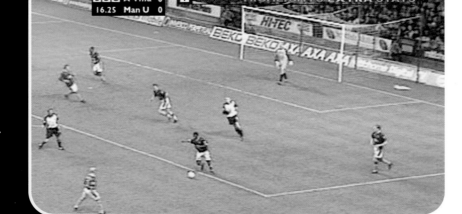

(RIGHT) **A minimally sized interactive-features menu works at the top of the picture, away from the action. Strong colors allow the links to stand out, without the visual intrusion of a background bar or graphic element.**

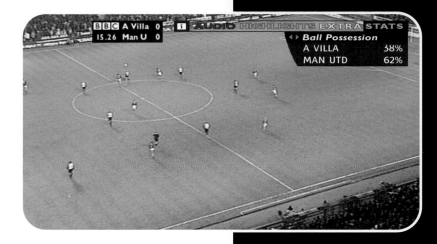

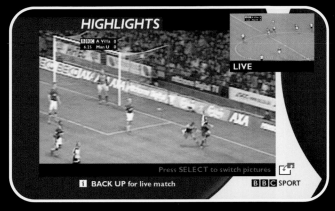

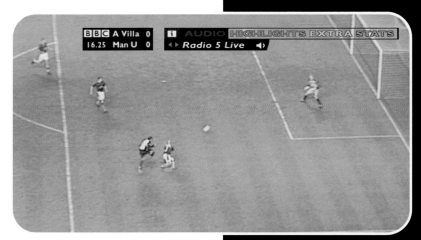

(TOP LEFT) **A stat screen that drops down from the main bar is where viewers go to scroll through all the game statistics in one place.**

(BOTTTOM LEFT) **The audio-options drop-down menu allows viewers to choose from the televised audio, the radio broadcast audio, and stadium ambiance with no commentary.**

(TOP RIGHT) **By using the picture-in-a-picture feature, fans can review game highlights without missing any of the live action. Either image can be enlarged or reduced.**

[**Solution**] The Football Association Cup interactive service lets viewers explore alternative viewing options while watching live coverage of the competition. Viewers can change the commentary or turn it off, choose different video options, or overlay live statistics on the screen. The interface was designed to work in wide-screen, letterbox (when a black frame is at the top and bottom of the screen), and center cutout (like a clack frame on four sides). The viewing options can be accessed only from the live match. This allowed the designers to keep the navigation very simple and the structure very flat. The on-screen color keys provide quick access to alternative video streams whereas the left and right arrow keys enable the viewer to explore audio options and statistical information.

Judging by viewer feedback, the service has proved successful, and the format has been reproduced as a template for rugby's Six Nations Championship and the forthcoming World Cup interactive service.]

Mike McDonald > **Interactive Television Designer**
Vlad Cohen > **Head of Design**

SPIDERDANCE

By Tracy Fullerton
President, Spiderdance, Inc.

Convergence Programming on Two Screens

Over the past three years, Spiderdance, a Los Angeles-based interactive-programming company, has developed and launched a number of the most successful convergence programs to date by synchronizing online content to television broadcasts. Companies like NBC, AOL Time Warner, Viacom, A&E Networks, and Sony have created award-winning and audience-driving programs using this "two-screen" method of convergence.

These programs target an existing viewer base—the 44 million people who currently surf the Internet on a PC and watch TV in the same room at the same time. While the development of the set-top-based iTV market has been and continues to be constrained by the slow pace of deployments by MSOs, this "telewebber" market has grown dramatically over the past several years. Currently, there is a large viable market for interactive television in the U.S.

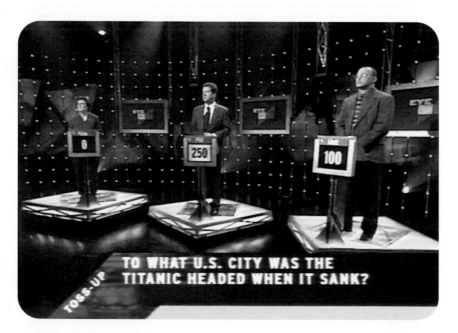

TO WHAT U.S. CITY WAS THE TITANIC HEADED WHEN IT SANK?

Here are some statistics from studies of the PC/TV market:

1. Forty-four million Americans surfed the Web while watching TV in 2000, reports DataQuest.

2. Cyber Dialogue (now Fulcrum Analytics) found that U.S. online adults reported being online simultaneously during 44 percent of their TV viewing time in 2000.

3. Twenty-seven percent of adults between the ages of eighteen and thirty-four reported in 2000 that they "surf the Internet and always or often watch TV at the same time," according to Scarborough/Arbitron. ▶

4. Nielsen//NetRatings: In 2000, 76 percent of all
U.S. households had two or more TVs, and 41 per-
cent had three or more.

Two-screen PC/TV programming offers a unique
opportunity for advertisers to reach the so-called
telewebbers, who are a sought-after demographic group.
Cyber Dialogue reports that the typical telewebber is
between thirty and forty-nine, has an above-average
income, and is an aggressive online buyer. This valuable
demographic is difficult to market to, because their busy
lifestyles demand that they compress their use of media;
simultaneous PC and TV use is a key part of this. When
telewebbers watch TV, their attention is divided.
Simultaneously marketing via PC and TV increases the
viewers' retention of marketing messages.

PC/TV programming is also proven to increase viewer
retention. Our Cyber Bond interactive programming for
the Turner Broadcasting System (TBS) Superstation's
James Bond marathon showed that viewing times were
two-and-a-half-times longer for PC/TV iTV users than for
TV-only viewers. Users also spend an average of thirty
minutes per session playing our always-available content,
which is offered even after the television program the
content is based on goes off the air.

While we at Spiderdance have focused on the
existing base of PC/TV viewers, our shows can also
be deployed on set-top boxes, wireless devices, cell
phones, and home networking products. As the market

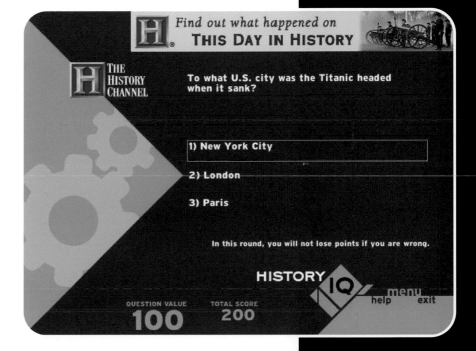

for iTV programming on these devices grows, our two-screen programming will expand to include one-screen
and multiscreen models.

Our vision is that the viewers will make the ultimate choice of how they wish to access iTV programming.
Viewers who feel most comfortable with a one-screen interface will be able to use set-top boxes as they become
available. Younger or more technology-savvy viewers may feel more at ease using their online PCs, cell phones,
or wireless devices. Whatever the platform, the content and community surrounding the experience should be
consistent and rewarding. This is the goal that we keep in mind when developing all of our iTV experiences. ⌋

In the late 1990s, a number of studies showed that a surprising number of homes had televisions and PCs in the same room, often running simultaneously. Spiderdance takes full advantage of this "two screen" phenomenon by using a unique combination of technology, content, and design. ▶

(ABOVE) **The set design enhances the industrial, high-tech, futuristic concept of the show.**

158 QUESTION???

2 wrong answer

3 right answer

4 wrong answer

[Challenge] MTV understood that their audience was already multitasking—that is, using a personal computer while they watched TV—and they wanted to create programming that spoke to this trend. Just as MTV twenty years earlier had helped to usher in a new era of cable television with innovative programming and design, *webRIOT* was conceived to be one of the first examples of the increasingly shortened distance between the television and computer. The concept for *webRIOT* was that in-studio contestants and online users could view music videos pulled from past and present rotation on MTV and respond to a variety of questions and answers that appear on the screen. Online users could play live against the show's broadcast by watching MTV for the questions. The online game would be synchronized to the TV show, allowing at-home users to answer questions at the same time as the in-studio players. ▶

Tracy Fullerton > **Producer/Creative Director**
Pete Campisi > **Lead Programmer**
Steve Hoffman > **Interactive Design**
Jeff Vock > **Graphic Artist**
Timothy Lee > **Quality Assurance Manager**
Rob Davis > **MTV Online Executive Producer**

Mike Gresh > **Technical Director**
Steve Sessions > **Senior Programmer**
Vincent LaCava > **Art Director**
Michael Sweet/Blister Media > **Sound Design**
Anthony Ko and Eric Kim > **Software Testers**

TOP TEN
ONLINE PLAYERS

OsakaG	2250
BADFISH	2250
friligan	2250
SuperWang	2250
DrewDoGGbG	2250
Luticrus	2249
DonIsHere	2248
FantomLord	2241
lyrical2K	2241
PODeath	2241

desrt*FLWR 2200

(LEFT) A contestant at home is video-linked to the on-air game, and scores from the online game are posted to involve the at-home players in the broadcast.

[Solution] Before *webRIOT*, live, massively multiuser convergence programming had never been done, and no one was quite sure where the pitfalls would be. Spiderdance had already spent a lot of time trying to anticipate problems in designing the technological infrastructure, but they knew there were bound to be unexpected issues along the way. According to Tracy Fullerton, president and founder of Spiderdance, "The most important thing was to make sure that the players experienced a flawless integration between the television show and the online game, and that the experience was as stable and usable as turning on your television."

The goal for Spiderdance was to make *webRIOT* a completely integrated experience, so they chose to make the online graphics look exactly like the on-air graphics. This meant that players could look from their TV to their PC and instantly know how to play along. The challenge with this was that every time a change was made to the on-air graphics, the designers had to make a corresponding change to the online graphics. In the end, though one of the best features of the application was that it achieved the goal of being an instantly recognizable interface to the game.

Because broadcast-safe colors are limited, the Web-game designers let the television palette dictate the colors they used for the interface and graphics. Once the colors were established for the broadcast show, the designers chose the best matches from their computer-based palette. ▶

From a technical point of view, the production broke new ground in almost every aspect of its design. The greatest challenge was to achieve the kind of frame-accurate synchronization that the gameplay demanded. Due to the precisely timed appearance of the matching graphics on PC and TV as questions were asked, it was very easy to notice even a small discrepancy between the timing of the Web experience and the broadcast show. The technology for this sync-cast was carefully developed to display frame-accurately on all systems, regardless of processor power, connection speed, or Internet latency.

The show was extremely well received—in terms of both on-air ratings and online usage. Over 1 million people registered to play, an extremely large number by online standards. Because there was a 24/7 version of the game available, users could go in at any time to practice, chat, and get to know each other.

"The production arcs of television and interactive software are very different," Fullerton explains. "In television design, the concern is on getting the live elements created and shot—in most situations the graphics are married to the video in postproduction later in the process and are not the top priority early on. In interactive software, it is the reverse: the graphics generally define the interface and features. These need to be created early in the process so that the engineers can integrate them. How you deal with this difference will ultimately determine how well the on-air and online graphics relate to one another."

According to Fullerton, the overwhelming response to *webRIOT* was "We want more." "What we realized pretty quickly was that we needed a lot of content to keep the 24/7 community happy," she says. "We also learned some key usage lessons, which we have since incorporated into future programs. These included letting users chat during gameplay, showing them each other's scores in a leaderboard, etc. These types of community-focused additions have added to the experiences we deliver."]

(RIGHT) **The graphics for the home-user interface are kept simple, bold, and consistent with the on-air design.**

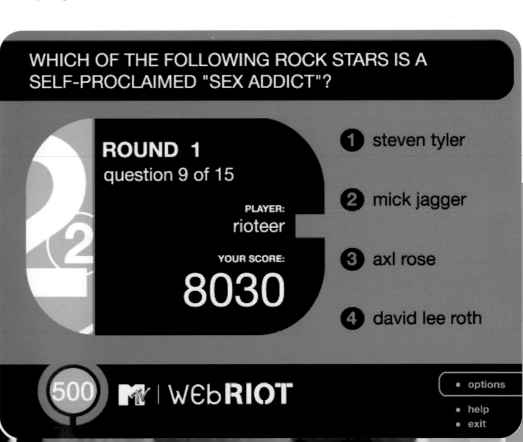

The sync-cast concept not only allows the broadcaster to synchronize online features with individual programs, it also lets interactive features be synchronized with interstitials, commercials, and promotions between the programs. In the case of Cyber Bond, the interactive features tied together ninety hours of James Bond films by engaging the community of viewers in an ongoing event that held their interest between films. ▶

[**Challenge**] For the TBS Superstation James Bond marathon, Spiderdance was asked to produce an interactive multiplayer game synchronized to coincide with elements of the broadcast promotion.

The James Bond marathon broadcast ninety hours of Bond films over fifteen days. For the online version, the concept was to produce Cyber Bond, a test of wits and knowledge that would allow avid Bond fans to show off what they know about all things Bond. Cyber Bond's intended viewership included hard-core fans, many of whom are among the 44 million people who simultaneously surf the Web on a PC and watch TV. The interactive game Infiltration sends online users on challenging, 007-like assignments, and features chat, game playing, and a chance to win prizes. ▶

(LEFT) **The Cyber Bond game and TBS's URL were advertised on television during the James Bond marathon.**

(RIGHT AND BELOW)
The main game screens provide branding, rules, set-up, and game-playing information.

SIGN-IN

CYBER BOND

TBS SUPERSTATION

15 days of 007

sbclark ▼ — SCREEN NAME
**** — PASSWORD

SAVE PASSWORD

SIGN IN

NEW MEMBER REGISTRATION

HELP

EXIT

GAME ENTRY

PLAY CYBER BOND

GAME RULES

CYBER BOND

PRIZES

HALL OF FAME

TURN AUDIO OFF

GAME RULES

EDIT PROFILE

SCHEDULE AND AIR TIMES

PRIVACY POLICY

CREDITS

How to play 007 OPS:

- 007 OPS trivia questions will appear in Cyber Bond throughout each Bond film
- Click on the correct answer within the 30-second time limit
- The points you receive for a correct answer will be based on the time left on the clock; the sooner you answer, the more points you receive. If you answer correctly, then the points remaining on your Question Score will be added to your Total Score
- Be careful: Incorrect answers will cost you points! If you answer incorrectly, then half of the points remaining on your questions score will be deducted from your Total Score. If you do not make an answer selection, then no

CLOSE

HELP

EXIT

TBS Superstation, Inc./Spiderdance Inc.

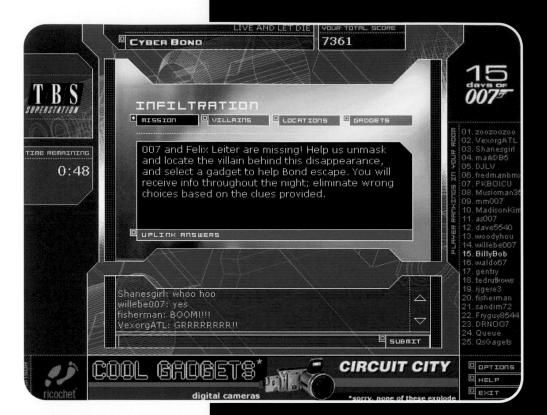

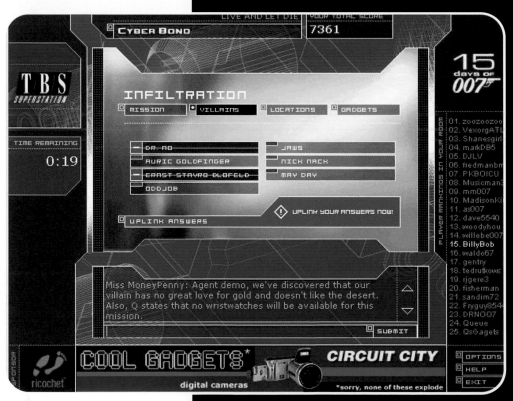

(LEFT) **An overview screen reveals the complexity of efficiently combining chat, gameplay, a player list, game options, a timer, and ad banners on one screen.**

[**Solution**] So the interactive component would enhance the movie experience, each quiz question was directly related to what was happening on-screen when the question was posed. Because the broadcast and online experiences intertwined in this way, it was critical to have frame-accurate synchronization between the TV and the PC. Spiderdance's proprietary technology enabled the game to run frame-accurately on all systems, regardless of processor power, connection speed, or Internet latency.

Each evening, a Clue-like mystery game played out during the Bond movies that were broadcast, lending the game a sense of intrigue. Players who watched an entire evening's movies could collect all the clues, use them to solve the mystery, and then enter a nightly contest. The online graphics were designed to look like sleek, metallic communications devices that would reflect the trademark 007 high-tech gadgetry and cutting-edge espionage technology. Because the broadcast component's graphics were similar, consistency between the two resulted.]

(RIGHT) **Miss MoneyPenny communicates—"live"— some vital mission clues during commercial breaks. This keeps the user involved, and the game remains dynamic until the program returns.**

(LEFT AND BELOW)
**This scene from the
broadcast of a daredevil
boat chase was
accompanied online by a
related trivia question.**

(ABOVE AND RIGHT)
During a chase scene involving a mysterious motorcyclist, the online game asked players about the helmeted rider's hair color. As the rider stops, pulls off the helmet, and shakes out her long, red hair, the answer is also revealed online.

LIVE AND LET DIE
CYBER BOND

YOUR TOTAL SCORE
716

QUESTION SCORE
739

15 days of **007**

007 OPS_QUERY

What is the hair color of the rocket-launching motorcyclist?

a. Blonde
b. Brunette
c. Red

Question 03 / 76

PLAYER RANKINGS IN YOUR ROOM
01. zoozoozoo
02. VexorgATL
03. Shanesgirl
04. markDB5
05. DJLV
06. fredmanbmx
07. PKBOICU
08. Musicman35
09. mm007
10. MadisonKim
11. as007
12. dave5540
13. woodyhou
14. willebe007
15. **BillyBob**
16. waldo67
17. gentry
18. tedrutkows
19. rjgere3
20. fisherman
21. sandim72
22. Fryguy8544
23. DRNOO7
24. Queue
25. QsGadgets

Shanesgirl: whoo hoo
willebe007: yes
fisherman: BOOM!!!!
VexorgATL: GRRRRRRRR!!

SUBMIT

T B S SUPERSTATION

48H4_10847 68

COOL GADGETS*
digital cameras

CIRCUIT CITY
*sorry, none of these explode

OPTIONS
HELP
EXIT

ricochet

Interacting with history

Client > The History Channel **Developer** > Spiderdance
Platform > Two-Screen Interaction **Project Title** > History IQ

When Spiderdance produced *webRIOT*, an interactive game show for MTV, they knew it would be easy to entice the young, tech-savvy audience into trying the innovative concept. But how would the same basic format go over with the older, more intellectual, and more conservative audience of The History Channel? ▶

[Challenge] The History Channel is a cable network that bills itself as a place "Where the Past Comes Alive." and The History Channel and Spiderdance launched a broadcast and online game show entitled *History IQ*.

 History IQ was created to challenge the trivia skills of viewers in what its producers pronounced the "hardest game show in history." In-studio contestants answered questions relating to all things historical, as did viewers at home playing on the simulcast version.

According to the show's producers, this game was designed to appeal most to true history buffs; they noted that the average player finished with a negative score. ▶

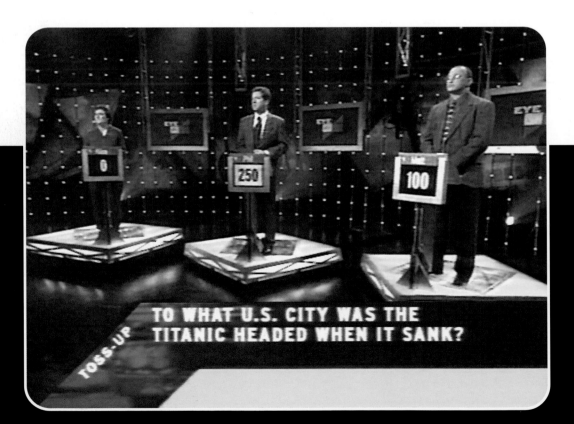

TO WHAT U.S. CITY WAS THE TITANIC HEADED WHEN IT SANK?

TOSS-UP

(LEFT AND OPPOSITE BOTTOM)
In order for the game to be fair for the players at home, questions are posed to the contestants on the broadcast game and the online players at the same time.

A&E Television Networks, Inc./Spiderdance Inc.

(ABOVE AND RIGHT) **The design of the interface for the home player had to address dual communications challenges: how to involve the user in competition against both the broadcast contestants and other online players simultaneously.**

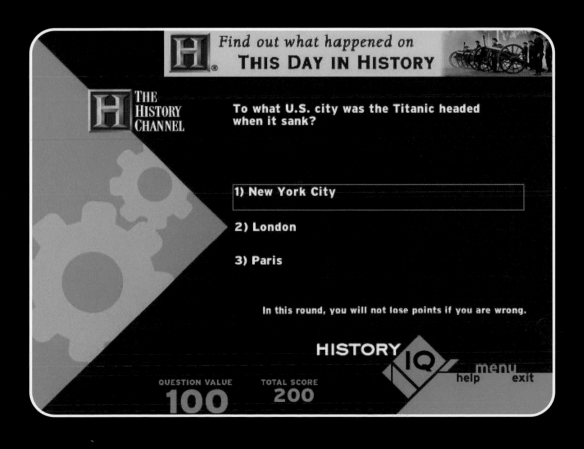

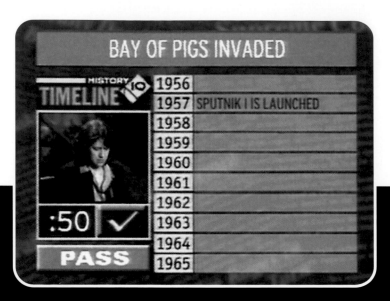

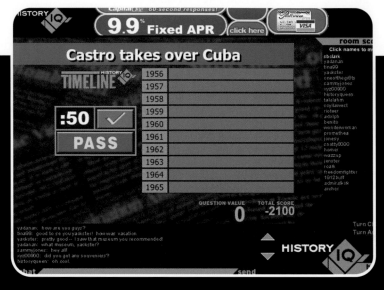

(ABOVE AND RIGHT) **In the Timeline round, players at home and in the studio try to answer within the allotted time, which is kept by synchronizing the clocks for both versions.**

(BELOW AND RIGHT) **In this Timeline round, users in the studio and at home "drag and drop" ten historical headlines to match the appropriate years. This unique technique involves online users in the same tension-filled, bonus-round event that is happening on TV.**

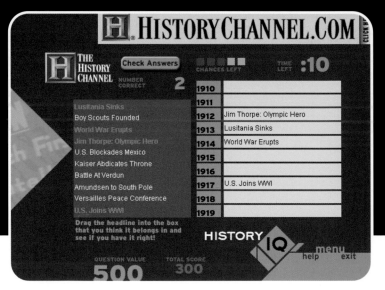

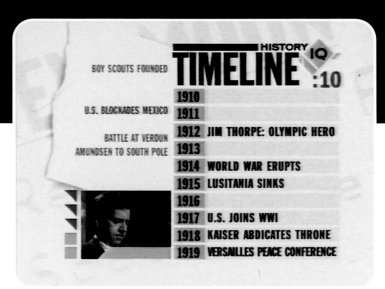

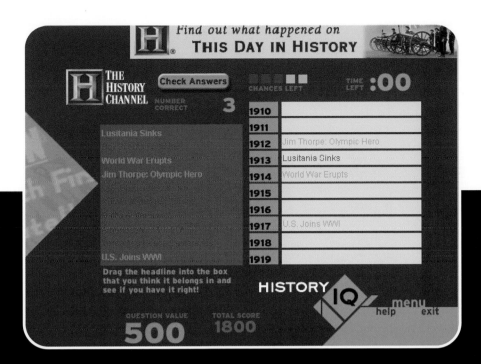

(ABOVE) **Color cues indicate whether the events are placed with the wrong or right years.**

(RIGHT) **All the screens are simple, clean, and strongly contrasting, and have easy-to-use navigation devices so viewers and players don't get distracted or lost.**

[**Solution**] *History IQ* (like Spiderdance's first two-screen interactive show, *webRIOT*), was designed from the beginning to be a convergence experience. Producers of the broadcast show worked closely with the Spiderdance creative team to ensure that visual and game-playing consistency between the broadcast and online versions was achieved, so the same group of artists created both designs. Another focus of the system's construction was keeping the interactive contest fair with frame-accurate synchronization between the TV and the PC.]

Fans of television's *Weakest Link* aren't content to sit at home watching the host abuse and humiliate the on-air contestants. Wouldn't it be great if there was place where know-it-alls from across the country could gather to jeer at and insult each other as one community? Throw in a virtual host who manages to be condescending in real time and you've got yourself a winning formula for a multiplayer game show.

[Challenge] Spiderdance developed for NBC's *Weakest Link* a fully integrated Internet and television convergence experience that brings home the brutally honest hit TV game show for those tuning in online during the show. Now players at home can be insulted right along with the players on the broadcast show. ▶

This site requires the Macromedia Shockwave Player.
If the Weakest Link Sign In Page does not appear after the animation finishes, your browser may not be capable of playing the Weakest Link. Please consult the Weakest Link FAQ for further information.

(ABOVE) **The intimidating visage of the show's host plays an important role in setting the mood for the game.**

(RIGHT) **Unlike the broadcast version, the online version requires the use of a multiple-choice format due to the amount of time it takes to type and the possibility of spelling or syntax errors causing a correct answer to be rejected.**

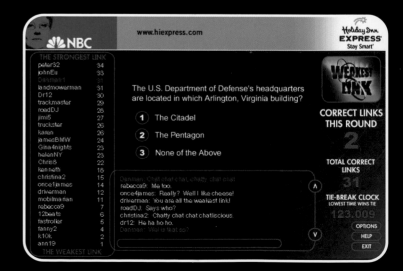

Susan B. Clark > **Producer**
Pete Campisi > **Lead Programmer**
John Eubanks > **Programmer**
Harry Taningco > **Programmer**
Dan Ewen > **Writer**
Peter Constantineanu > **Animator**
Francis Nickels > **Show Operations**
Chris Swain > **Executive Producer**
Michael Sweet/Blister Media > **Sound Design**

Tracy Fullerton > **Creative Director**
Mark Bennett > **Programmer**
Gina Gernant > **Programmer**
Chris Valley > **Programmer**
Rob Davis > **Writer**
Timothy Lee > **QA Manager**
Matt Crytzer > **Senior Show Administrator**
Tracy Fullerton > **Executive Producer**

Michael Gresh > **Technical Director**
Ken Czenis > **Programmer**
Steve Sessions > **Programmer**
Dan Fiden > **Writer**
John Rocco > **Animator**
Sam Day > **QA Tester**
Amber Mitchell > **Show Administrator**
Steven Hoffman > **Executive Producer**

[**Solution**] At-home players answer *Weakest Link* questions in sync with the broadcast, chat with other players, see their own and other players' scores ranked in real time, and find out if they are the game's weakest or strongest link. They can also vote on which of the on-air players should take the dreaded Walk of Shame and, of course, be pummeled by the host's clever witticisms regarding the extent of their trivia knowledge.

The interactive designers incorporated the show's icily sarcastic host into the online component, as she is an important feature of the visual identity, concept, and content of the game. The anxiety at the center of this game is based as much on a fear of being humiliated as it is on competition. This concept was not lost on the show's producers, and they effectively carried it through to the online version.]

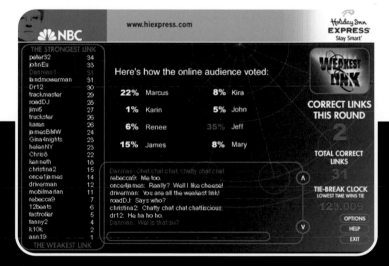

(LEFT) **The online audience gets updates on live polls, such as this one regarding the fate of a broadcast contestant.**

(BELOW LEFT) **In keeping with the spirit of the show, an unlucky online player is singled out for abuse. Although interaction during the game is limited to text only, fans of the show recognize the trademark sarcasm.**

(BELOW RIGHT) **The "live" host reacts to taunting that's taking place in the chat feature. That the virtual host seemingly reacts "live" in such situations adds realism to the program.**

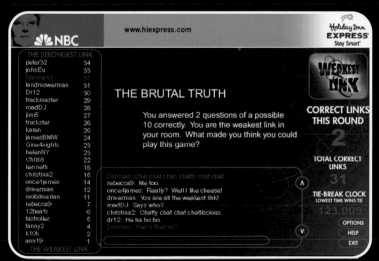

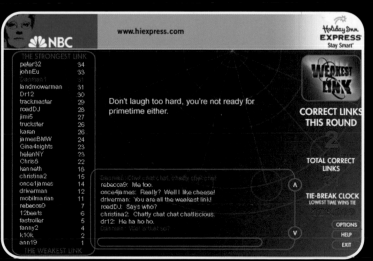

BROADBAND

The reality of broadband to date

is that it doesn't deliver a radical new development in Internet connectivity, but it does make the Internet experience a lot less annoying than it used to be.

But for many home users who have always connected to the Internet via a dial-up modem, there is an enormous difference between the "click and wait" Internet experience of old and the broad, speedy service broadband enables.

Early users of broadband have demonstrated how consumer online behavior changes with "thicker" (higher-bandwidth) access

and offered a glimpse of what high-bandwidth content, services, and features users respond to, and are willing to pay for.

With faster, "always on" connections to the Internet, home users spend significantly more time online. But what is surprising is how much more. Users who switched from narrowband to broadband increased their page views by 130 percent. In January 2002, broadband Internet usage in the U.S. outpaced narrowband for the first time, according to Nielsen//NetRatings, as broadband accounted for 51 percent of the 2.3 billion hours spent online during the month.

As home users change to broader connections, their online preferences change as well. Studies show that interest in entertainment and financial services increases, with users spending more time conducting online banking and performing ▶

stock-market-related activities. Broadband users are downloading music, playing video games, and, increasingly, viewing streaming media.

Significant for marketers is that broadband is eroding the power of television in the home by pulling women away from the television. A study by Jupiter Media Metrix and the NPD Group found that 44 percent of wired mothers said that online activities decreased the amount of time they spent watching TV. Instead, they use the Internet to help children with school-work, play games, and download music. In addition, for the first time ever, a poll of high-school students revealed that given the choice of giving up television or Internet connectivity, a majority would rather give up their TV. For teens, being cut off from E-mail and instant messaging alone probably would equal social exile!

The growth and development of this "tuned in" broadband audience will mean that demand will increase for more interactive and robust online experiences, impacting e-commerce, the streaming video industry, and Internet content overall.

Should design firms abandon their narrowband sensibilities and stop worrying about page download times? Not any time soon. The size of the broadband audience isn't predicted to surpass narrowband until 2007. Unless the context of a project clearly calls for a broadband audience, the general Web audience, which will be further polarized by connecting with anything between a 14.4 modem to DSL, will continue to be affected by download times. But it does mean that at the very least, there will be an increasing number of opportunities to make media-rich options available for both consumer and corporate Web sites.

A playground of ideas

To develop content for these opportunities, design firms will need to expand their sets of skills and services to include such things as script writing, video design and production, music production, streaming technologies, 2-D and 3-D anima-tion, and even game development.

On the content development side, broadband offers interesting opportunities for delivering content directly to the consumer. While cable operators have been struggling with how to implement, roll out, and make money off of interactive television, broadband connectivity has allowed savvy content producers to deliver the content and services that iTV had promised. By offering these services (such as video-on-demand) directly to the consumer, content producers not only avoid the infrastructure difficulties that accompany iTV, they also cut out the middleman (the cable opera-tor). And they get a preview of what customers respond to and will be willing to pay for in the future.

While the broadband Internet is not interactive television, it does have the unregulated and accessible creative experimenta-tion that iTV may never have. So while consumers wait for a compelling reason to adopt iTV and cable operators look for serv-ices that consumers will pay for, broadband remains the play-ground of ideas for today, which could become killer applications for the set-top of tomorrow. ⊐

H DESIGN

In surveys that ask what features interactive television users would be most interested in receiving, video-on-demand consistently ranks among the highest. Watching what you want to when you want to is an exciting prospect for customers, as well as for the entertainment companies eager to charge a fee for the content and convenience of the service. As vast archives of programming and film are translated into digital libraries available to consumers, the challenge for designers will be to make the experience of searching these vast libraries and selecting a film simple, easily navigable, and enjoyable. ▶

Delivering simplicity on demand

Client > Intertainer **Developer** > H Design **Platform** > Internet **Project Title** > Intertainer Site

(RIGHT) **The Intertainer splash animation is a tinted montage of scenes and titles from some of the premier offerings on the site. This screen establishes the color palette and the horizontal letterbox (film ratio) shape of the content area. The shape lends the site a cinematic air because it resembles a theater screen.**

[**Challenge**] Intertainer delivers the largest on-demand selection of movies, music videos, television programs, and concerts to televisions via digital cable, a high-speed connection that makes downloading and watching a streaming feature-length film a reality (for a fee). Intertainer was looking for a comprehensive navigational structure that would allow users to access more than sixty-five thousand hours of programming from more than seventy content providers, including film, television, and record companies. Providers of this aspect of the entertainment industry will inevitably face fierce competition from major entertainment companies, so Intertainer needed a Web presence that would help the company define its position as a leader in the video-on-demand market by establishing a strong identity and an easy-to-use, customer-friendly site. ▶

(ABOVE) **The log-in screen also "teases" the viewer with the diversity of the content available. Oftentimes, the log-in and password fields are thrust in front of the user in a way that screams, "KEEP OUT!" This example is far friendlier and keeps nonmembers (who can preview features) engaged with the site without losing the functionality of the log-in.**

Dale Herigstad > **Creative Director**
Robert H. Sanborn > **Executive Producer**
Erin Williams > **Producer**
Rudy Manning, Colette Arimoto > **Designers**

[Solution] H Design delivered a simple, fast-loading interface that emphasized the featured content and included options for additional information and downloads. The interface allowed users to screen previews, control the size of the preview window, and view other relevant options all on the same screen.

The biggest challenge for the design firm was determining how to deal with the vast number of categories and movie titles available through the site. "While Intertainer is more geared toward broadband, you end up with an interface that may seem more like a Web site," explains H Design's Dale Herigstad. "It gets down to that because you have so many categories, and so many titles. For instance, if you are to click on a category like ACTION and see what's inside, there's quite a few choices there. So you have to find simple ways to categorize, organize, and display options." Although Intertainer is designed to work on a computer, H Design also developed a version with larger lettering for television, because some broadband users hook their PCs to their televisions so they can fully enjoy services like Intertainer in the comfort of their living room. **]**

(BELOW) **The welcome screen establishes the left margin for searching and listing finds and the top of the screen for the menu choices, which are branded with colors from the established category palettes.**

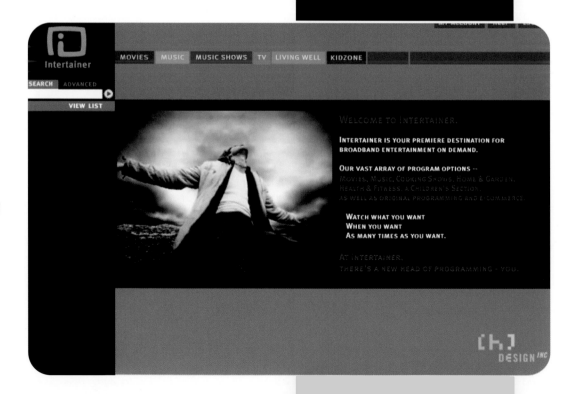

(RIGHT) **The color branding from the menu button is carried through in the background color and links in each section to help the user identify their location in the site. Links in the left-hand menu present the user with options to see movie previews, information, tie-in merchandising, and similar titles.**

R/GA INTERACTIVE

One of the most exciting and eagerly anticipated features of broad-
band and iTV television is multiplayer games and entertainment. Online gaming has become
enormously popular on the Internet, with legions of loyal fans logging hours of playing time
inside, for example, the virtual aerial combat of Kesmai's Air Warrior or online bloodbath tour-
naments like Quake, Marathon, and Doom. But if multiplayer is to have appeal beyond the
"shoot-'em-up" market, multiuser games need more mass-market and cerebral appeal. Game
shows have had long-running mass-market appeal on television, and the idea of users "buzzing
in" from home has always positioned game shows as an ideal application for multiuser technol-
ogy. In 1997, R/GA Interactive was involved in converting two of television's most popular
game shows into online multiplayer games, the success of which proved that online multiplayer
games can appeal to a mass-market audience by providing mass-market content. ▶

Getting into the multiplayer game

Client > Sony **Developer >** R/GA Interactive **Platform >** Internet
Project Title > *Jeopardy* and *Wheel of Fortune* Online Games

[RIGHT] **The introduction
animation sets the tone for
the show. The designers
avoided creating a literal
interpretation of the familiar
classic by updating the look
and personality so they would
be appropriate for the
context and the demographic
of the audience.**

[Challenge] Sony challenged R/GA Interactive to turn the world-famous *Jeopardy* and *Wheel of Fortune* games, two of television's longest-running shows of any genre, into online multiplayer games. While the two game shows had existed previously as interactive game shows on virtually every video-game platform, Sony was interested in bringing the games into the multiplayer arena with a compelling look and feel that would appeal to a new audience of players. Because the games would be "live" online and generally played from home, they would have to be designed for low-bandwidth home-connection speeds. Because of the low bandwidth, the games would have to be presented without photographs or 3-D animation. Both games were to be the anchor entertainment vehicles inside the gaming area at Sony's site. ▶

(ABOVE) **Each player chooses his or her own avatar (on-screen graphic representation) and can interact with other players through chat. The chat content appears in a cartoon balloon above the player's avatar.**

(LEFT) **While the producers gave *Jeopardy*'s identity and attitude a facelift, they wanted to keep the game board and gameplay the same, since one of the biggest strengths of the brand is the audience's familiarity with it.**

【 **Solution** 】 R/GA Interactive developed colorful, retro-style Java-based applications that bring the excitement and challenge of multiplayer games to the Web. The graphic and comic visual designs give each game a hip, distinctive, and exciting identity that is unique from both the broadcast and previous video-game versions of the shows. The games' interactive avatars allow players to express their personalities, maximizing live-chat interaction among the players. These games quickly became the most popular multiplayer games on the Internet in 1997 and continue to have hundreds of thousands of dedicated registered users today.

Some of the graphic and interactive elements of the Web show were so well received that the producers of the broadcast show considered integrating them into the television version. 】

(ABOVE) **With a feature called Avatude, a combination of the words** *avatar* **and** *attitude,* **a user picks the facial expression for their avatar to display— smiling, laughing, or frowning. Use of this feature is similar to the use of** *emoticons* **in online chat or E-mail, where combinations of letters and punctuation marks are employed to depict facial expressions, helping to communicate the writer's tone.**

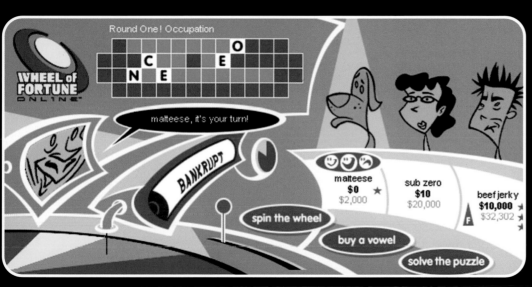

(ABOVE) **While the gameplay for the online** *Wheel of Fortune* **is the same as that for the broadcast show, the graphic style is fresh and exciting. It's also of technical benefit since photos or rendered 3-D images would have resulted in a larger and slower download.**

(ABOVE AND RIGHT) **As with the online version of** *Jeopardy,* **the designers changed** *Wheel* **somewhat, here by eliminating the ubiquitous Vanna White and Pat Sajak, but remained true to the familiar rules and gameplay. Each player chooses from several expressions to enable their character to display emotion.**

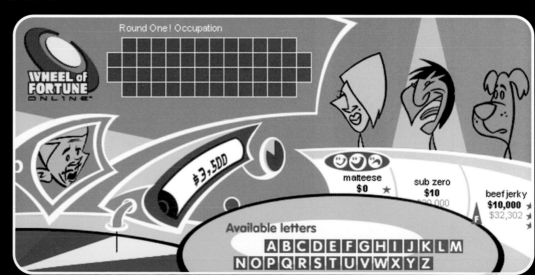

Game shows have been one of the most consistent and reliable ratings grabbers since the beginning of television. When Microsoft first launched the Microsoft Network (MSN), it designed the online service as a metaphor for television,

(BELOW) **In this game, contestants match categories with fragmented answers. A message box announcing who "buzzed in first" adds to the live-TV feel of the show by making the game reactive and competitive between the live players.**

(RIGHT) **Nick Marvelous, the animated host, warms up the crowd. The puzzles and interface are rendered in the same retro style as the host and background. In this example, the puzzle resembles the pattern of an old-fashioned argyle sock. The online players' scores and ranks update dynamically while an online timer counts down.**

〔 Challenge 〕 Microsoft was looking for original and compelling online content capable of drawing users to MSN. Ideally, this content would inspire repeat visits and create a sense of online community that would develop into a base of loyal and active MSN users. The experience would have to be conceptually, creatively, and technically different from the games already available for free on the Web. While multiplayer text-based games had been available on the Web before, nobody had attempted to make the interaction inside a visual, animated environment feel like a game show. *NetWits* preceded Shockwave and Flash, so many of the animation and multiuser features were developed from scratch. ▶

R/GA > **Design and production**

(RIGHT) **Players can duke it out in a graphic adaptation the children's game Rock, Paper, Scissors with icons such as water, fire, paper, scissors, and dynamite.**

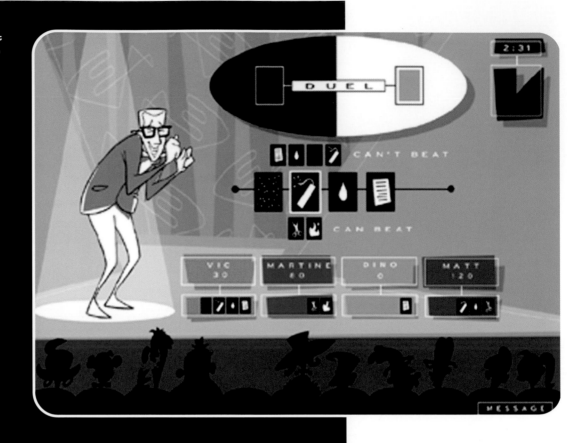

[Solution] R/GA Interactive conceived of and developed the original game show concept for *NetWits*. *NetWits* was the Web's first multiuser online game show, complete with a hipster host, real prizes, cool animation, and funky music. Participants became online contestants in this multiplayer tournament that gave everyone a chance to win free round-trip airline tickets and other prizes. To add to the televisionlike presentation, the show was "broadcast" every weeknight at 10 P.M., in contrast to the majority of Internet entertainment, which is available 24/7. Between episodes, single-player practice challenges were available on the site. ▶

The game featured the charming host Nick Marvelous, an animated version of 1960s-era game show hosts, who passed along hints, wisecracks, and encouragement to contestants in the game. Each day brought a different game—a word hunt, a jumble, a checkers-like game, and more. By keeping the games in rotation, the producers gave players a reason to visit the site daily.

The sharp retro-styling, party atmosphere, and intense gameplay of *NetWits* made it one of the only successful properties on MSN. The game was designed to be simple, visual, and easy to understand and play.

NetWits enjoyed a loyal fan base and won many industry awards and much critical praise, including being selected by *Time* magazine as one of ten "Best of the Web" sites in 1997. 〕

(LEFT) **The patterns and textures of the background were worked into the tiles on this board game. The animated crowd appears to alternately cheer, jeer, taunt, and laugh.**

A quality exhibition of art relies not only on the art itself, but also on the curatorial approach and tone of the exhibition to lend context and meaning to the art. The pacing, positioning, and presentation of the art are painstakingly considered to add the most value to the viewing experience. In most online presentations of art, however, the viewer is given little context to help him or her gain a fuller understanding or appreciation of the artist. ArtMuseum.net has attempted to bridge the gap between real and virtual exhibitions by creating a Web site at which major works and exhibitions can be seen in a rich and interactive environment. ▶

R/GA > **Design and production**

[Challenge] With Intel as a sponsor, R/GA was put to the task of developing an immersive and navigable 3-D gallery of the works of Vincent Van Gogh. The firm sought to create an experiential gallery that, by inviting exploration and learning, transformed the museum experience. Their goal was to create an online gallery that would educate, excite, and motivate cognoscenti and new-comers alike. ▶

(OPPOSITE AND RIGHT) **The site is designed to keep users informed about where they are in the gallery.**

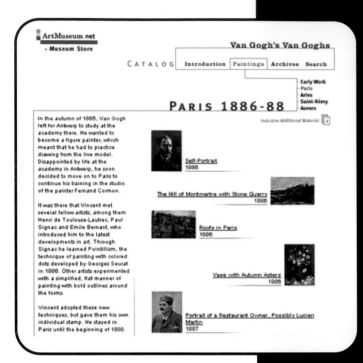

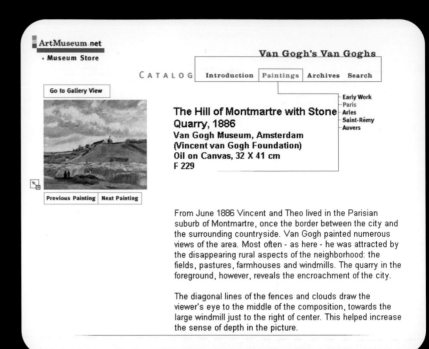

[**Solution**] R/GA created a content-rich, interactive environment that plunged visitors straight into the artist's world. The online exhibit featured a 3-D gallery where visitors toured the van Gogh exhibition exactly as it was constructed at the National Gallery of Art in Washington, D.C. The design encouraged users to explore the exhibition at their own pace and to zoom in to view paintings in detail. Inside the gallery, a visitor could navigate throughout ten virtual galleries, engage in real-time text-based chat, or take a guided audio tour of selected works in the exhibit. In addition, by closely collaborating with the Van Gogh Museum in Amsterdam, R/GA created 3-D versions of *The Bedroom* and *The Yellow House* that allowed visitors to "step into" the paintings and navigate inside their simulated environments. ▶

(OPPOSITE AND RIGHT)
Users can view each painting in detail and purchase copies in the museum gift shop.

The Web site presented biographical information about the artist and his career, as well as a virtual exhibition catalog containing background information on every painting in the exhibition and archives that included sketches, photographs, letters, and other material from the Van Gogh Museum and the Vincent van Gogh Foundation. The archives also linked to the paintings.

The Gallery section of the site was the navigable portion that recreated the exhibition at the National Gallery of Art. Here, viewers could find zoomable images of the paintings and audio files with additional information about selected paintings and periods in Van Gogh's career. Search utilities were available for accessing all the content on the site, as was a museum store that offered for sale an assortment of products related to the exhibition. The site brought the content to life by using rich-media technology, like RealPlayer for streaming audio and video, LivePicture for zooming in for close-ups, and the G2 viewer for additional multimedia enhancements. ❏

An ideal form of content to work with when adding interactive functionality is the documentary. Documentaries are meant to be informative, educational, and engaging, and to permit the user to develop a deeper understanding of the subject matter, and interactivity can advance all of those goals by adding more detailed and related content. The art of creating a documentary lies in knowing what to leave out, and what to leave in. Because the viewer has options to explore various aspects of the subject more deeply, he or she can play an active role in determining how the documentary is presented and how much information is conveyed, much as producers and directors do when filming. ▶

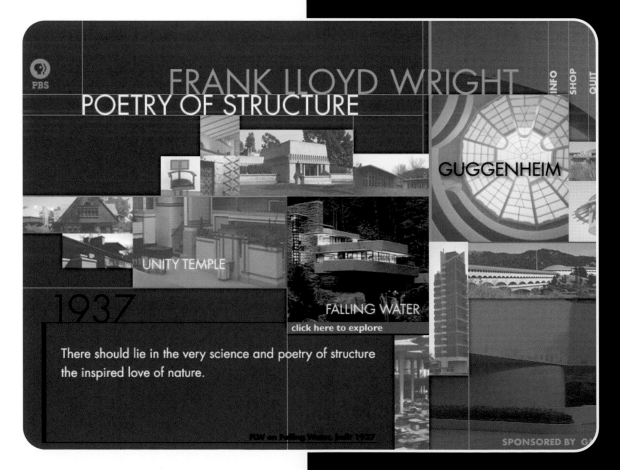

(LEFT) **The intro and main menu screen on the Frank Lloyd Wright site shows photos of structures that are featured. The screen comes alive as the grid reacts to the user's moving the cursor, bringing into the foreground color images of the buildings, the dates of their completion, and relevant quotations from the architect, such as here, with the masterpiece called** Falling Water. **A menu positioned neatly at the upper right of the screen features links to online shopping and additional information while the large text in the background moves in an animated scroll.**

[**Challenge**] In 1999, R/GA Interactive developed one of the first educational/ entertainment projects designed specifically for broadband. The objective was to develop an interactive companion piece to Ken Burns's PBS documentary on celebrated architect Frank Lloyd Wright. Of critical importance was creating a rich learning experience using high-speed digital technology that could deliver the quality that viewers expect from a Burns production. The project was developed as a "proof-of-concept" for Intel's ill-fated Intercast system and was shown to a test group of Intercast users.

Intel's Intercast was a method of television/Internet interaction that had the support of many companies in both industries. With Intercast, television broadcast signals would include Web pages and other bits of information relevant to a particular program.

An Intercast browser would receive the signal, display the TV feed (through the Intel Intercast hardware), and cache the Web pages so the viewer could delve more deeply into a program's subject matter as it aired. ▶

(BELOW) **The link to the Guggenheim Museum project expands the menu system at the upper left with options for viewing content and commentary about the museum. Each structure's home page features a large image of the exterior and thumbnail views of the interior, plus a building blueprint with "hot spots" that take the user to various QuickTime 3-D views. These views appear on a grid that allows the user to view the museum from any direction.**

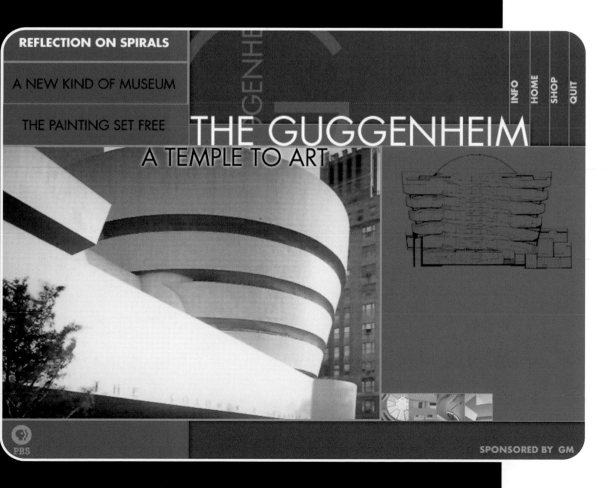

the SPIRAL

[Solution] R/GA created a virtual tour of the architect's most famous building, the Guggenheim Museum, incorporating a level of interactivity that was not possible with television and including video, text, and QuickTime virtual reality tours. Equally important was the comprehensive interface that allowed users to easily navigate through the building, incorporating the horizontal stratification that characterizes Wright's distinctive work. The R/GA design team worked with Ken Burns's production company to select aspects of the documentary that would work best in the interactive format.

One of the biggest challenges facing the designers was that the interactive component was not incorporated into the documentary itself. Instead, the interactive options were presented to viewers at the end of the piece, which meant that the designers had to find ways to link the documentary with the interactive content. From this experience, the designers learned that ideally, they should work with the production company from the beginning to more fully integrate the interactive components.

Although Intel's Intercast was short-lived, the Frank Lloyd Wright project stands as an excellent example of the potential of broadband applications. **]**

(ABOVE) **An animated introduction to one section describes the concept behind the museum's controversial spiral design.**

(ABOVE) **The introduction screen for a section that focuses on the architect's use of cubes in his designs features an animation of repeated thumbnails of Wright's work that visually relates to the gridlike repetition found in the cube imagery.**

(LEFT) **The shopping link takes the user to a section where they can purchase items related to the Wright documentary and other PBS productions. Here, the designers employed an innovative method to present products to the users: thumbnails of videos of PBS documentaries tumble down the left side of the screen at a speed slow enough that users can see all of the selections and click on an item if they choose to. When a thumbnail is clicked on, details for the item appear on the right side of the screen.**

HEAVY.COM

Broadband offers creators the opportunity to develop and deliver niche content directly to niche audiences. While the market is still in its infancy and business models have not yet taken hold, the medium's creative visionaries have been willing to "jump in first" with innovative ideas to see what the market can support. For three years, Heavy has been filling bandwidth with irreverent, media-savvy content with an attitude, and has built a strong base of loyal fans and clients along the way. ▶

Living large

Client > Heavy **Developer** > In-House **Platform** > Broadband **Project Title** > Heavy.com

Team Heavy

〔 Challenge 〕 In 1998, Simon Assaad and David Carson teamed up to form Heavy Industry, an interactive advertising firm and broadband digital broadcast network, to explore opportunities in the broadband space for advertising and original content that would draw users to corporate Web sites. The firm quickly made a mark with a rich-media, Flash-based campaign for IBM through Ogilvy Interactive that won many of the top industry awards. The partners then looked for opportunities to integrate "the big idea" into alternative forms of advertising, such as animated advertisements or short, original Internet clips, which viewers "virally" forward to friends and family, thus spreading the advertisers' messages.

One of the first concepts they developed was an online show called *You Suck*, which enabled users to berate people by E-mailing them cards that were available in the online show. Unable to find the appropriate corporate home for the concept, Carson and Assaad hit upon the idea of creating a site that felt more like a network as a place to promote the show to corporate marketing departments. Other shows they created also would be posted to tempt potential clients. ▶

(OPPOSITE PAGE) **Sumo wrestlers, an integral component of the Heavy identity, are used as fun identifiers on loading sequences, merchandise, promotional materials, etc.**

(TOP) **Because Heavy.com is loaded with animation programs, audio, and interactivity, the site uses Flash extensively for its rich-media capabilities. This scene is from a Heavy.com program entitled *Munchy Man and Fatty*.**

(MIDDLE) **A scene from *Behind the Music that Sucks*, a parody of VH1's *Behind the Music*. The graphics style is intentionally rude and crude, adding to the humor.**

(BOTTOM) **A *Behind the Music that Sucks* episode features Kid Rock and his former sidekick, Joe C. The combination of celebrity photographs and animation means the designers can put anybody they want in any situation they want. The mock-seriousness of the voice-over track completes the parody of VH1's *Behind the Music*.**

[Solution] In 2000, the partners launched a broadband digital entertainment network, Heavy.com, as a way to show advertisers how they could reach a specific, ready-made audience through broadband entertainment.

The pair's mission was to create new advertising and marketing vehicles to deliver messages to the under-thirty audience. The idea was to create brands, create context, and create programming that would attract an audience and keep their attention. In the words of the founders, "It's not rocket science, it's entertainment."

They decided to create a site that didn't feel like a Web site—one that didn't have a lot of text or information. It would be more visual and straightforward, similar to a television.

According to Graham Johnson, head of Interactive Client Services, "We were really trying to emulate what we would like to see in convergence as far as the set-top box. Since the conception, the thing for us has really been, 'Why can't we do that?' Whereas on the services side we would be conservative and worry about things like size, here it was more like, 'What is too big? Don't worry about it, just do it.' It's allowed everybody here to explore what the medium could be. ▶

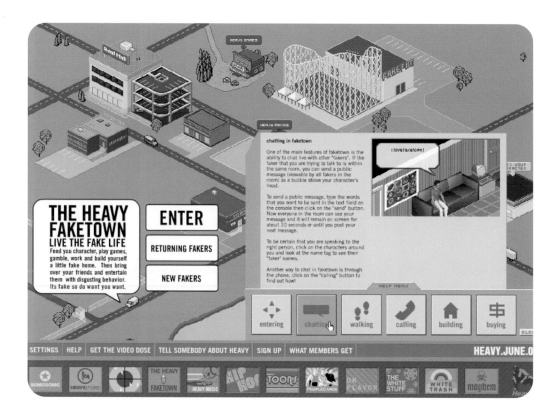

(ABOVE) **With users accessing Heavy through broadband speed, there no reason for community chat to be a text only interaction. Heavy Faketown allows players to "live the fake life." Visitors are represented on screen with a personalized character which interacts with other visitors inside of the virtual community. In the words of the Faketown intro: "feed your character, play games. Gamble, work, and build yourself a fake home. Then bring over your friends and entertain them with disgusting behavior. It's fake so do what you want."**

(TOP LEFT) Heavy.com's simple menu system keeps all the channels available as buttons across the bottom of the screen. The channels' main menus are designed to provide clear, intuitive, and visual navigation.

(BOTTOM LEFT) A title screen from a Heavy Show called *Heavy Petting*. The show's title and brand identity are worked together in a provocative title illustration.

(TOP RIGHT) The main menu screen for Heavy Shows features individually branded show identities. These content areas look completely different from month to month, but the shows' identities stay the same.

(BOTTOM RIGHT) The title screen from a live-action, episodic program called *Stella* that Heavy distributes. Stella is a sketch-comedy troupe that performs in New York. Users can play the current episode, or one from the archive of past episodes.

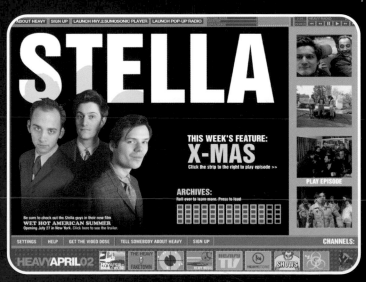

"If we're going to do something like this," he continues, "we shouldn't worry about bandwidth, and instead concentrate on doing the best work we can. Especially for things like video—who wants to watch video on a screen that's like, an inch by an inch, five frames per second?"

Heavy.com became a calling card for Heavy Industry's service business, attracting companies interested in advertising and marketing projects based on the unique style found on the site. Team Heavy was created to accommodate these clients.

Heavy.com is a labor of love for the company's employees. While the site has been a great tool for attracting business on the services side, it is not supported by advertising, though it is partially funded by a subscription base. In return for a monthly fee, subscribers not only get access to Heavy.com, they also get a "Heavy Box" in the mail every month, which includes a music CD hand-selected by Heavy as that month's featured artist or artists.

According to Creative Director Ryan Honey, "The only thing that constricts us is the time we can put toward it. With the amount of time we spend with it, it is really up to the people behind it to make it great. If we could spend an unlimited amount of time on it and not have to do service jobs, it would be amazing. But the service work pays the bills and keeps the company going forward."

At the time this writing, the Heavy.com network receives nearly a million visitors per month, and Heavy's original entertainment is distributed on home video and DVD.]

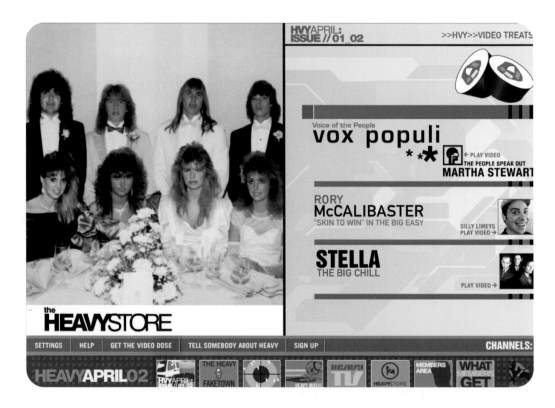

(ABOVE) **The Heavy Store is irreverently illustrated with a classic early 1980s prom photo. For the designers, the beauty of working on Heavy.com is having the freedom to *not* make sense, which, of course, isn't possible with client work.**

(TOP LEFT AND RIGHT) **The event presentation was created in the form of an interactive "3-D ProductFirst-Viewer," a parody of the 3-D View-Master. By clicking on and dragging the reels to the viewer and then clicking the advance bar the viewer loads and displays a presentation that includes details about and screen shots from the new product release, as well as examples of products that have been designed using the software.**

(BOTTOM) **The call-to-action of the promotion is the event registration. The registration "pops up" when the user clicks on the always-present registration tab. The registration box background is slightly transparent, which helps to communicate to the user that they have not changed location in the site.**

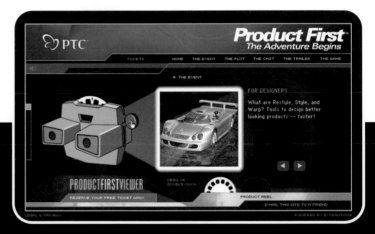

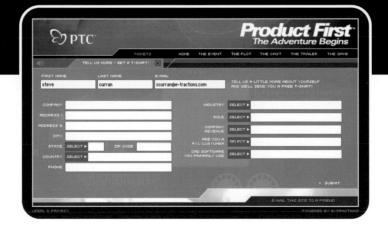

by an HTML E-mail blast that drove visitors to the promotions posted at the microsite. Also at the microsite were additional details about the seminar and an online registration area for those who decided to attend.

In all, 48,000 unique visitors went to the microsite 1.3 times and spent an average of 7.7 minutes there, for a total of 600,000 minutes of brand exposure.

The trailer—produced in Flash in the style of a movie preview, was designed to entice viewers to sign up for the Web seminar.]

WIRELESS

It's hard for graphic designers

to get excited about designing for wireless handheld devices and personal digital assistants (PDAs). Just when increased broadband availability and Flash started to make the Internet more fun, along come new platforms that seem to offer all the design freedom of the pre-Mosaic Internet. The possibilities for creatively designing visuals for wireless devices are limited because the platform is still fairly new.

At the moment, at least in the U.S., the content displayed on

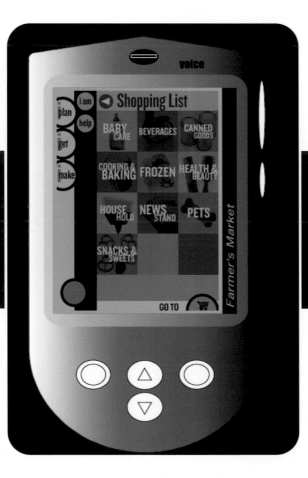

wireless devices is mainly static, text-based information. But just as the Internet evolved from blinking text and tiled backgrounds to the rich-media experience of today, advancements in wireless devices, their software, and their network infrastructure will transform the face of wireless into one loaded with rich animation, sound, and even video-based content. For inspiration, designers need only look at the potential offered by third-generation (3G) bandwidth, like NTT's DoCoMo i-mode which allows subscribers to download and play online games, as well as receive high-resolution still images and music files on their Web-enabled wireless phones.

The true designers of the handheld-computing experience to date are the information architects, who take one of the most challenging sets of circumstances for interaction and come up with clear, simple, and comprehensive communication. The user's experience is defined by how well the structure and hierarchy of accessing options and content have been designed. ▶

While this is true for every interactive medium, it is even more so for handheld devices, which have little room for luxuries like complex menus, submenus, and navigation graphics. At least for now.

The big ideas

For years, we've been hearing about the wireless future, when all of our appliances, entertainment units, and communication devices will be connected.

But simply incorporating wireless enhancements into a product doesn't guarantee that product's success. Personal preferences and cultural influences, not just new technology or effective marketing, have a hand in determining what users will respond to. That's why different cultures have adopted the available technologies in different ways. In Japan, phones are seen as extensions of personality, with unique faceplates, ring tones, and desktop pictures. In Western Europe, voicemail and short messaging service (SMS), which permits transmission of short text messages between cell phones, are popular. In the U.S., voicemail is a popular feature, but SMS, changeable ring tones, and screen icons are not nearly as prevalent. U.S. users view their phones as primarily voice tools rather than content devices—today, anyway. Only a few years ago in the U.S., cell phones were considered gauche, showy displays of wealth or self-importance. Now, they are standard equipment for businesspeople, parents, and students. These things have a way of sneaking up on us and becoming ubiquitous.

But the wireless revolution goes well beyond new applications for phones and PDAs. In the wireless living room, all entertainment is managed by a central hub that stores and wirelessly transmits video, music, and the Internet to a variety of wirelessly networked devices. In the future, these new home-entertainment networks (HENs) will offer even more functions, like digital video recording and E-mail, and wirelessly manage your video camera, digital camera, MP3 player, and home stereo.

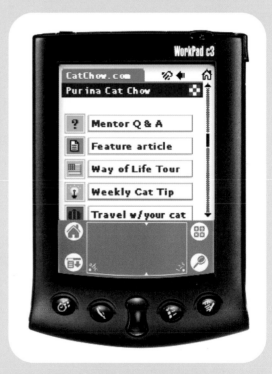

Cars will increasingly feature *telematics*, the auto industry's term for connecting onboard computers in automobiles to mobile phones, satellite navigation systems, and the Internet. Drivers can ask these units to read them their E-mail or schedule or make stock trades, all through voice commands. Retailers dream of sending you localized promotions as you pass by their store in your car.

Games have already proven to be wildly popular on these devices, with students beaming games on handheld devices and bored business travelers playing dice games on their cell phones. Datamonitor's wireless gaming research led the market-research firm to estimate that the current practically nonexistent wireless-game market in Europe and the U.S. will grow from practically nothing to a staggering $6 billion by 2005. The report states that wireless gaming could become the single biggest factor driving the adoption of 3G mobile devices.

What the developers and designers of 3G content need now are easy-to-use content-creation tools and development standardization that will allow more creators and developers to produce innovative and surprising new applications. ⌋

AGENCY.COM

Text messaging has proven to be one of the most popular applications for wire-less devices. In Europe, SMS has been an enormous hit with consumers, but it has yet to be fully tapped as an opportunity for branding. For marketers looking toward a future when wire-less Internet will offer opportunities for location-based promotions (advertising delivered to people in or near a store, product, or retail destination), text messaging has provided a sneak preview of the possibilities. The challenge to marketers is: How do you take a primarily text experience and make it interesting, innovative, and a full-fledged vehicle for branding? ▶

Text-in to win

Client > Interbrew **Developer** > AGENCY.COM
Platform > Wireless Text Messaging **Project Title** > Heineken Promotion

[Challenge] Interbrew wanted to promote its Heineken beer in an attention-grabbing way that positioned the brand at the cutting edge. As is the case with most clients when they tap into new areas of marketing, Interbrew had included no money for experimentation in their budget. The client wanted five key criteria to be fulfilled in the campaign: The promotion had to be innovative, quickly deployable, cost-effective, and had to position the brand's identity at the cutting edge, all without interfering with the operations of the pubs and clubs where the promotions would take place. The latter concern was particularly important to Interbrew since the company relies on those establishments to stock and sell their products. ▶

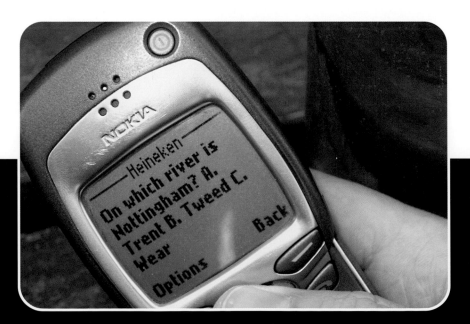

(LEFT) **Trivia game questions transmitted via wireless appeared on players' phones.**

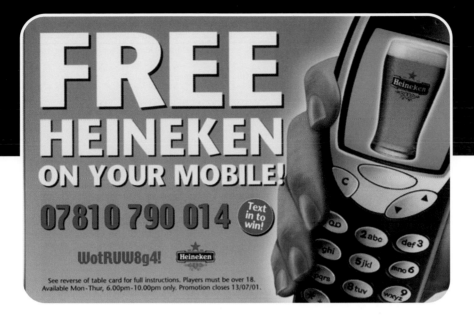

FREE
HEINEKEN
ON YOUR MOBILE!
07810 790 014 Text in to win!

WotRUW8g4! Heineken

See reverse of table card for full instructions. Players must be over 18.
Available Mon-Thur, 6.00pm-10.00pm only. Promotion closes 13/07/01.

(LEFT) The wireless game was promoted on tent cards placed on tables in participating pubs. The cards included the "coded" message "WotRUW8g4!" which users of text messaging know means "What are you waiting for!"

[Solution] Today, the Heineken brand is associated with the explosive popularity of text-messaging trivia games that followed Interbrew's promotion. AGENCY.COM's concept was to engage pub patrons in a trivia game played by answering questions delivered by text messaging to their cell phones. Successful players won pints of Heineken. By using text messaging in this way, Interbrew initiated a direct dialogue with pub and bar customers, engaged consumers at the "point of purchase," and moved the Interbrew brand to the cutting edge of promotion.

AGENCY.COM had a lot of confidence in their ability to pull off the unique promotional concept. The firm's Applied Concepts Lab had already created a text-messaging trivia game prototype, which also featured a unique real-time fulfillment system. This meant that AGENCY.COM not only had a working prototype to demonstrate to the client, but it also had a considerable head start in developing a production version of the game. So, with a working version ready to be customized for the brand, Interbrew purchased a four-week campaign for 500 pubs across the U.K. The text-message game, unique among Interbrew's promotions, is a digital interactive promotion with a real-world call to action and immediate fulfillment. The advantage to the client of a prototype having already been built was enormous. The costly trial-and-error process of developing a concept for a new medium had been done prior to the client's involvement, so AGENCY.COM could accurately establish a cost for the project.

Interbrew and AGENCY.COM produced the world's first pub trivia game delivered with SMS technology. Their accomplishment was noted as news in media throughout the world, further enhancing the general public's perception of the Heineken brand. Pub customers throughout the U.K. obviously enjoyed the game experience, with the average player playing three games averaging seven minutes in duration each night. ⅃

AGENCY.COM: Applied Concepts Lab

An unconventional solution

Client > eTravel Developer > AGENCY.COM Platform > Internet, PDA, Telephone, and Wireless Application Protocol
Project Title > San Antonio Convention Center

Travelers often visit Web sites for information and to make accommodations before hitting their destination. But wouldn't information on what to do and where to eat be even more valuable if it could be accessed on non-Web interfaces during a trip? ▶

(ABOVE) **A Flash introduction shows off San Antonio's playful identity, which the designers wanted to highlight.**

[Challenge] When eTravel invited AGENCY.COM and four other agencies to present redesigns of the San Antonio Convention Center's Web site at an industry conference in Orlando, Florida, it wanted to show the conference attendees what a convention bureau for a midsize city like San Antonio could do on the Web with $150,000. Rather than providing a glossy makeover, AGENCY.COM seized the opportunity to demonstrate how information transferred across multiple digital channel solutions such as Web sites and wireless applications can enhance both the user's experience and the relationship between the user and the site's owner.

According to Creative Director Chris Needham, AGENCY.COM redefined the challenge in their own terms: "How do you put somebody into an alien place, a three-dimensional city via online, which is a two-dimensional space, and give them a sense of being in that city, and show them what's available? Then, if we can have this immersive experience online, how can we ratchet the experience down into information that can travel with you, into your PDA, into your phone? How can we link those two worlds together?" ▶

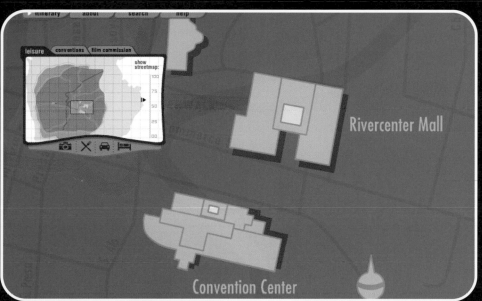

leisure conventions film commission

show
streetmap:

100

75

50

25

00

Rivercenter Mall

Convention Center

(TOP) **The orange background
is a blowup of the map of San
Antonio. The floating console**

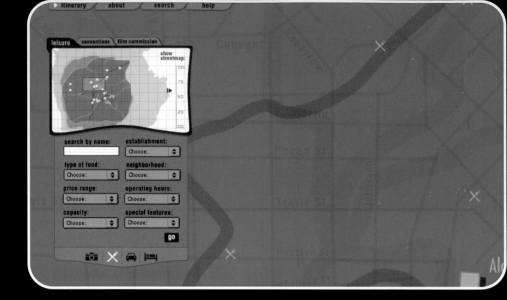

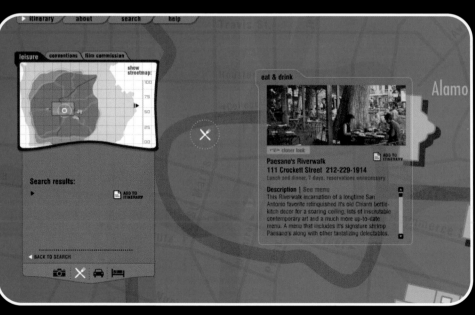

(TOP) **Selecting one of the icons at the bottom of the console makes a menu of options drop down. Users can refine their searches with parameters such as food type and price range. The map to the right of the console displays knife-and-fork icons to show the locations of restaurants meeting the search criteria.**

(BOTTOM) **When a restaurant is selected, a second console unit appears and brings up photographs of the interior, a description of the restaurant, a menu, the hours of operation, and other pertinent details. Additionally, a text banner that runs along the bottom of the**

[Solution] The multidisciplinary team spent six weeks creating a functional demo that uses a single source to deliver relevant content to four delivery channels: Internet, PDA, telephone, and Wireless Application Protocol (WAP) phones.

In researching what the city guides that were available online were like, the team found that the bulk of them are books, directories, or searches. The majority are books loaded online.

"The main thing we were trying to tackle was the shift from text-based communications to image-based communications," says Needham. "If you take the pretext that human beings understand images 70 to 90 percent better than they understand words, then it's clear that with a fatter pipe—with a broadband connection—you can begin to communicate more effectively, more emotionally, and with deeper clarity with image and text interaction than with text alone. We really wanted to do a guide that was much more kinesthetic and visual. So we started with the basic concept of a city, and how that city could be represented in geographic, visual ways, which, of course, is the map."

First, the team evaluated which channels were appropriate for an integrated solution. After selecting the four delivery channels to be used, they then evaluated how each would fit into the user experience. For example, a user probably wouldn't book travel arrangements through a PDA, but likely would use it to store itineraries and get directions. ▶

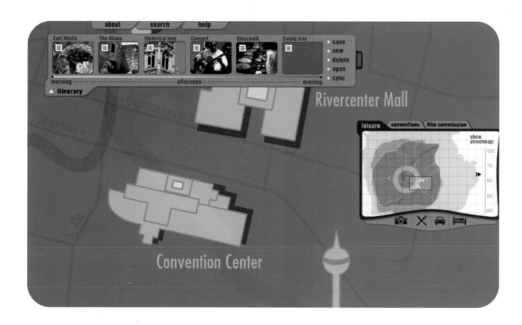

(ABOVE) **The itinerary console is a visual display of thumbnail views of selected locations. The itinerary can simply be glanced at, but details on individual items can also be accessed through the console. Items can be saved or deleted from the itinerary, and the console's content can be downloaded to a PDA by voice through a telephone or remotely through a wireless device.**

(TOP LEFT) **The introduction screen to the PDA version of the San Antonio travel guide uses a grayscale view of the branding from the Web site design.**

(TOP CENTER AND RIGHT) **After choosing EAT AND DRINK from the main menu, the user can search either by categories or more directly with keywords. Searches can be narrowed by selecting parameters for price, hours, and location from pull-down menus, which conserve space. The menu choices at the bottom of the screen include MY ITINERARY, which the user has downloaded after making selections on the Web site.**

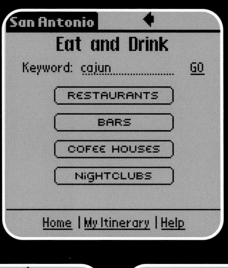

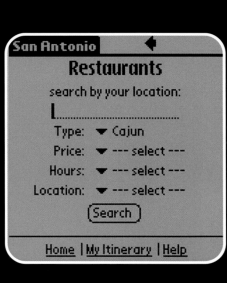

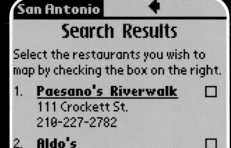

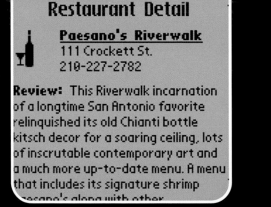

"The process of extracting the appropriate content base on the constraints of display was one of the biggest challenges from the technical standpoint of the information architecture," says Christopher Stetson, AGENCY.COM technical director, "but the amazing thing is to see an information architecture come alive as the designer takes it and makes it something wonderful."

In the presentation, the firm illustrated ways a user could obtain information on the Web (like finding Cajun restaurants in a particular part of a city) and then view that same information using another source, such as a WAP phone.

"The thing that we wanted to get to," says Needham, "was the connection between the lean forward medium of a computer, where I'm sitting at home, exploring and investigating, and preparing plans for my trip, and then quickly take that research and send it to a mobile device that then becomes an accessory to my trip. It's a drag-and-drop interface," he continues. "You can drag and drop information to a custom toolbar we created that can be downloaded to a PDA or accessed through a mobile device when you're in the city."

This downloaded information is stored in one database that's used across all the channels, allowing the user to consult a variety of sources, and eliminates the need for the same data to be published in multiple places. ⏎

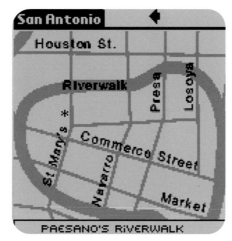 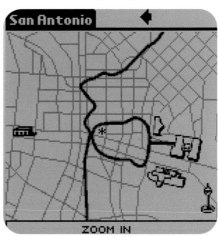

(THIS PAGE) **Users can also find attractions they know the locations of by viewing a map. Items selected in previous searches show up on the map.**

R/GA INTERACTIVE

The term *cutting edge* doesn't usually bring to mind cat food. However, R/GA and Purina found a unique way of enticing cat owners into a relationship with the Purina brand by offering interesting and relevant information across a variety of electronic platforms. ▶

A traveling community of resources

Client > Purina **Developer** > R/GA Interactive **Platform** > Mobile PDA **Project Title** > Purina Cat Chow Mobile

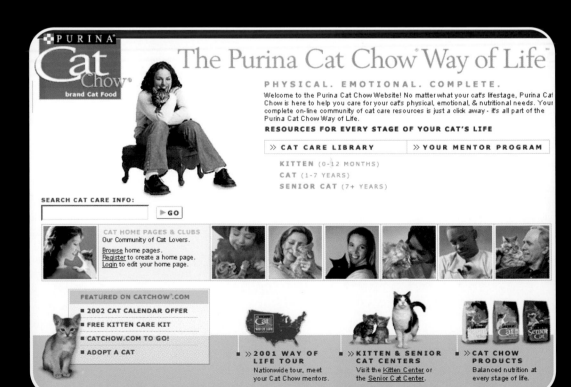

(RIGHT) **The Purina Cat Chow home page creates a feeling of community by showing a diverse group of cat owners with the felines they love, and points the way to valuable content.**

[**Challenge**] R/GA Interactive had designed and produced an ambitious and effective Purina Cat Chow Web site, but Purina wanted to find an innovative way to connect and interact with the growing number of cat enthusiasts who own PDA devices. The solution also needed to be an extension of the brand's marketing efforts, which emphasize building a community of resources and providing cat enthusiasts with the information they need to care for their pets' emotional, physical, and nutritional requirements. ▶

[**Solution**] R/GA created an application that uses the AvantGo Internet service to let cat lovers use their PDAs to access new content in the popular "Cat Care Library," "Cat Tips," "Your Mentor Program," "Kitten Care," and "Purina Cat Chow Way of Life Tour" sections of Catchow.com. At AvantGo's free portal, users of wireless devices can sign up for news, information, and entertainment channels and receive product information and promotions. Along with the main content areas that are made available via PDA, the Cat Chow channel also permits users to send questions to the Purina Cat Chow Mentors, a panel of feline experts who reply by E-mail. The mobile experience is integrated in promotions with the Purina Cat Chow Way of Life Tour, a traveling collection of resources that provides free education, information, and training to cat enthusiasts around the country.]

(TOP RIGHT) **This banner design features a tiny kitten to promote the small, "to go" version of the Web site available through portable devices.**

(BOTTOM) **On the mobile channel, the brand identity takes a back seat to content and functionality. A mobile device user wants useful and interesting information at their fingertips—a much more focused interaction than casual Web surfing.**

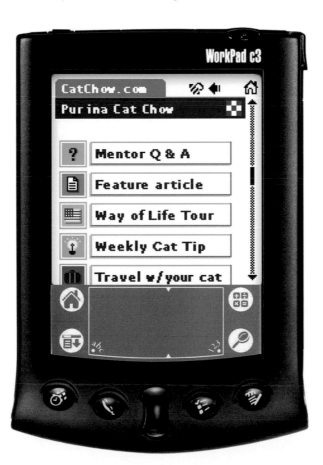

H DESIGN

One ambition of wireless-device designers is to influence the shopper at the point of purchase via localized wireless messaging from the retailer. Promotions, coupons, and sale prices could be communicated as effectively as if every customer had their own sales associate who knew their preferences and taste. With text messaging via PDA, the device aids the shopper by providing additional information so the user can focus on the goods in the store. The goal is to keep the necessary interaction with the PDA to a minimum to keep it from becoming an impediment in the shopping experience. To do that, designers need to create smart menu systems that can accept input in multiple formats, such as voice and barcode. ▶

A revolution at retail

Client > Odyssey Technology **Developer** > H Design **Platform** > Wireless PDA **Project Title** > iON

Dale Herigstad > **Creative Director**
Colette Arimoto > **Designer**
Andy Walraven > **Flash Animator**
Erin Williams, Santino Sladavic > **Producers**

(RIGHT) **A mosaic of options allows the user to search by category. The visuals behind the text permit easy identification and make the screen more appealing.**

[Challenge] In 2000, Odyssey Technology, Inc., was looking to create a user interface for its new product, iON, an unparalleled PDA-like handheld device that acts as a personal concierge and shopping assistant for the user. It finds the best deals on products, store specials, and product information, all based on the needs, interests, and purchasing history of the user. The voice-activated device creates a dialogue between the retailer and consumer at the point of purchase, in the store. One of the unique things about iON is that it accepts voice commands for navigating, but the client also wanted it to have a friendly, easy-to-use on-screen menu and environment that encourage a personal relationship to form between the user and the retailer. ▶

(BELOW) **The "i plan" mode organizes data into several categories. Even though the screen's graphics are good, the interaction still depends predominantly on text cues for some functions. The designers vary the sizes of the text menus to keep navigation clear and simple.**

(LEFT) **Lists can be called up with spoken commands. The icon at the upper right of the screen indicates that the menu is in voice mode and navigating by recognizing keywords spoken into a built-in microphone.**

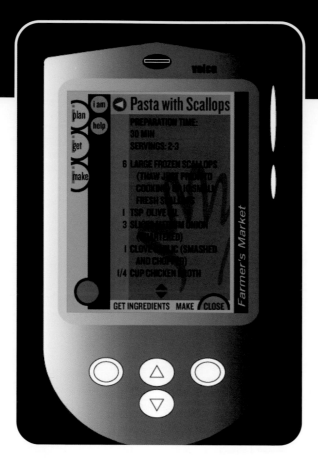

[**Solution**] H Design created an environment reminiscent of a warm, friendly, upscale store that gives its customers personal attention. The system the designers developed permits many of the user's commands to be entered by voice. For example, if a user thinks of an item, such as cereal and says "cereal" to the iON, various cereal products will appear on the touch screen, allowing the shopper to choose the one they want. The order can then be transferred to a store through the Internet, from which the retailer retrieves the list with the aid of his wireless Bluetooth connection and tells the shopper when his or her order will be ready. The iON can also advise customers of store specials and discounts.]

(ABOVE LEFT) **In the "i get" mode, the ingredients for a recipe can be called up—that's a particularly useful feature when you're at the grocery store. The hand outlined in the background signifies that the user is in the i-get section. Longer recipes can be scrolled with the UP and DOWN keys.**

(ABOVE RIGHT) **The "i make" mode brings up the recipe directions. A page counter reports the number of pages of instructions, and a timer keeps track of cooking times.**

(ABOVE LEFT) **With a pen stylus, the user can make notes in the address book by writing them freehand. Using a consistent grid device and gray-scale tones for the screen allowed the designers to include a lot of information and a wide variety of features at the same time, without cluttering the screen.**

(ABOVE RIGHT) **Electronic coupons save users money while the "add to cart" feature saves them time. To distinguish the coupon from the interface design, a more "promotional" feel is cultivated with unique fonts and type sizes larger than those used for other content on the unit.**

NTT DOCOMO

Advances in next-generation wireless standards will someday revolutionize how people around the globe work and live, making possible a world that today exists only in the realm of science fiction. In your leisure time, you'll be able to watch a concert or sports event in real time and download your favorite movies and games with a device that fits in the palm of your hand.

Soon, third-generation, or 3G, wireless services will connect video-enabled phone users from around the world for videoconferences and send and retrieve data and files while the user's on the move. On the way home from work, customers will connect to their home-automation systems and turn on lights, air conditioners, and other appliances, and control their home-security systems by displaying security monitor images on their cell phones. Users will even be able to check the contents of their refrigerator—and the expiration dates of the products in it—while en route to the store, submit their order ahead of time, and pay for it with an electronic wallet. ▶

A society transformed

Client > NTT DoCoMo **Developer** > In-House **Platform** > Cellular Phone **Project Title** > i-mode

[Challenge] Over the past decade, mobile communications technology has made giant strides, moving rapidly from analog first-generation (1G) voice-only communication to digital second-generation (2G) voice and data communication.

No place in the world comes closer to the vision of a society transformed than Japan. By May 2001, Japan's cellular phone market had 62 million subscribers, nearly half its population. Japan's market has grown faster than any other market of its kind in the world, and the country's NTT DoCoMo leads the way.

Soon after the industry's shift from analog to digital in the early 1990s, NTT DoCoMo pioneered the development of non-voice mobile communications with their DoPa, Japan's first "packet" data communications service. ▶

NTT DoCoMo

(LEFT) **This shows the Japanese interface of the wildly popular i-mode service, which allows users to read popular newspapers, check their bank balances, and find good restaurants. The i-menu is their gateway to the Internet. Viewable in Japanese or English, this user-friendly portal provides access to an ever-expanding wealth of content. With customizable screen images, such as this butterfly background, and personalized ringtones, the phone becomes an extension of the user's personality.**

Users can access four main categories of content with the i-mode, including:

(BELOW) **TRANSACTIONS:**
Money Transfer/Balance Check
Security Trading
Ticket Reservation
Airline Reservation/Seat Availability
Credit Card Information
Book Sales

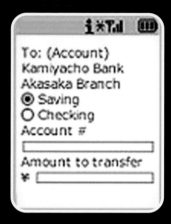

(BELOW) **INFORMATION:**
News Updates
Weather Forecasts
Sports News
Stock Quotes
Business/Technology News
Town Information
Horse Racing Information

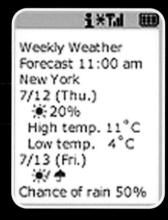

(BELOW) **DATABASES:**
Telephone Directory Search
Restaurant Guide
Dictionary Service
Cooking Recipes

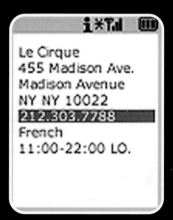

(BELOW) **ENTERTAINMENT:**
Character Download
Horoscope/Fortune-Telling
Karaoke Information/Hits Songs
FM Radio Information
Club Event Information
Download Ringing Patterns.

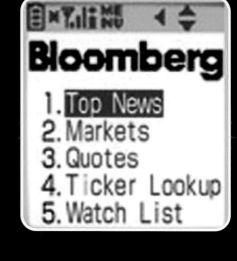

(THIS PAGE) **The i-menu connects users to a vast number of Japanese content providers and increasingly more English-language sites. By clicking on the i-menu, customers can read the latest local and international news from CNN,** *People's Daily* **(China), and the** *Chosun Ilbo* **(Korea), or review stock prices and dispatches from Nikkei News, Dow Jones Newswires, and Bloomberg. They can also check the balance of their personal bank account at Citibank and make travel reservations with Northwest Airlines. They can locate good restaurants in unfamiliar areas of Tokyo by searching the Tokyo-Q database. And, there's much more than just that. While the menus are mainly plain text, the graphic capabilities of cell phones allow content to be clearly branded.**

Anticipating that the cellular phone market would soon be saturated, the company stepped up its initiative to build new, innovative mobile data communications services for individuals. The challenge, as DoCoMo saw it, was to develop the leading application standard for wireless data transmission to position themselves for the next generation of wireless, which would revolutionize how people communicated, worked, and played. ▶

[Solution] The company created i-mode, a unique platform for mobile communications that gave cellular phone customers easy access to over forty thousand Internet sites, as well as to specialized online services such as E-mail, shopping and banking, reserving tickets, and getting restaurant advice. NTT DoCoMo's i-mode network structure provides access to i-mode and i-mode-compatible content through wireless or dedicated connections.

The i-menu (the i-mode services menu) connects users to a vast number of Japanese sites, and a rapidly increasing number of English-language sites. By clicking on items on the i-menu, customers can read the latest local and international news from CNN, the Chinese *People's Daily* newspaper, and Korea's *Chosun Ilbo*. They can review stock prices and dispatches from Nikkei News, Dow Jones Newswires, and Bloomberg, and check their bank balance at Citibank. They can make travel reservations with Northwest Airlines, find good restaurants in unfamiliar areas of Tokyo, and much more. With i-mode, there's instant and easy access to information, databases, and entertainment, as well as mobile financial transactions.

The new platform rapidly achieved an unparalleled level of acceptance, and two years after its launch, i-mode's popularity continues to grow dramatically. By May 2001, i-mode was an integral part of the business and personal lives of 28 million NTT DoCoMo customers. ▶

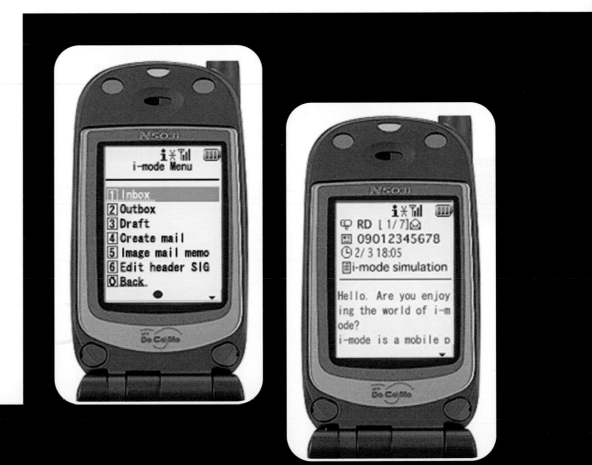

Now, with the arrival of NTT DoCoMo's FOMA (Freedom Of Multimedia Access) service in Japan, the 3-G mobile communications devices that have long promised to transform the way we work and live are finally becoming a reality.

The 3-G FOMA supports full-motion video image transmission, music and game distribution, and other high-speed, large-capacity data communications. Mobile videophone technology, enabling both video and audio communications, is also a reality with FOMA's real-time video transmission feature.

DoCoMo envisions a future when people around the world will benefit from borderless global communications, live-action video on mobile terminals, and even mobile control of home and office appliances. To this end, the company has initiatives in the works to bring i-mode services outside of the mobile phone arena and into places like the Sony Playstation, car navigation systems, even vending machines.

With partnerships that the company has formed around the world, such as the one with AT&T Wireless in the United States, NTT DoCoMo is hoping to ensure i-mode's future as the de facto global standard.

While the arrival of the wireless revolution has taken longer than anticipated, the success of DoCoMo's i-mode in Japan has given wireless entrepreneurs, marketers, and media companies the wireless industry's first look at a society transformed by the next generation of wireless services.]

BUZZTIME

For over fifteen years, NTN Communications has entertained millions of restaurant and bar patrons with live sports games and trivia delivered via its custom, networked interactive system. The NTN Internet games subsidiary Buzztime Entertainment now brings its popular content into the home on the Internet as Buzztime Network and on interactive television as Buzztime Channel. The company, always on the leading edge of convergent entertainment, wanted to close the loop with the first truly convergent game to let players in bars, online, on iTV, and on cell phones all compete inside the same multiplatform, multiplayer universe. The platform that could achieve this ambitious vision had to be able to integrate cell-phone users into the game. ▶

Performing without a net

Client > Buzztime Entertainment **Developer** > In-House
Platform > Cellular Phone **Project Title** > Predict-the-Play and Countdown Trivia

(RIGHT) **Shown here is the introduction to Predict-the-Play, a game in which players predict what will happen next in a live sports game. Players at a bar or restaurant equipped with the NTN network, at home at their computers, in front of their iTV-enabled sets, and on their BREW-enabled phones compete against each other in real time.**

[Challenge] Buzztime knew that restaurant and bar patrons liked its sports and trivia games, such as Countdown Trivia, Sports Trivia, and Predict-the-Play, on the NTN network, and they were also very popular on MSN TV (formerly WebTV) and online at Buzztime.com. But those platforms, even the somewhat limiting MSN TV platform, allowed for very graphic, visual presentations, an option not available with small-screened cell phones. Therefore, the designers had to find a way to make the cell phone content as simple and entertaining as it is on other platforms. And they also had to determine how to tie cell phones into Buzztime's mass competition technology so wireless players could participate in real-time games against players online in restaurants or on iTV. ▶

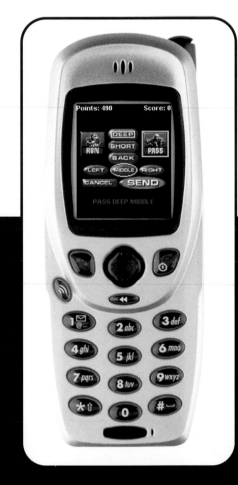 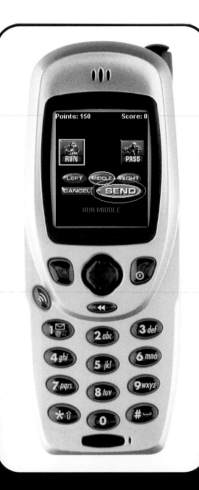

(LEFT) **Predict-the-Play is designed to be clear, simple, primarily text, and adaptable to various screen sizes.** Here, the player can predict whether the next play will be a pass or run, whether it will be sent to the left, middle, or right, and how deep it will go. The higher levels of specificity garner the player more points, so the scores of the players range widely.

[**Solution**] Because of the games' graphical and technical requirements, it was decided that the project would focus on BREW-enabled cellular phones. A product of QUALCOMM, BREW stands for Binary Runtime Environment for Wireless. The technology behind it is a solution for application development for wireless devices that enables such features as E-mail, video, music, and games to be available on portable devices. Although they were focusing on the BREW-enabled-phones base, the developers still needed to accommodate a wide variety of screen displays and multiple phone manufacturers. According to Buzztime Art Director Jaqai Mickelson, this made the designers' job interesting to say the least. "Every device had a different screen size and pixel count, which makes it difficult to write one program and make it look good on every phone. Also, the only universally supported image type on ▶

(RIGHT) **Shown here is the introduction screen to Countdown Trivia, a timed trivia game in which the more quickly you correctly answer questions, the more points you get.**

(RIGHT) **The lengths of Countdown's text messages vary, so the main branding screen is the only one with graphics. Because cell phones don't have the point-and-click advantage of the other platforms, the game is designed to let players quickly toggle to the answers and enter their choice.**

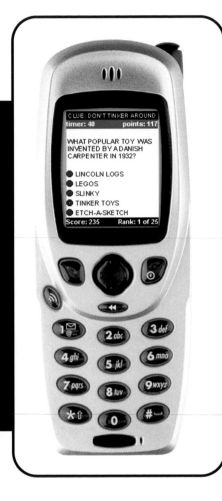

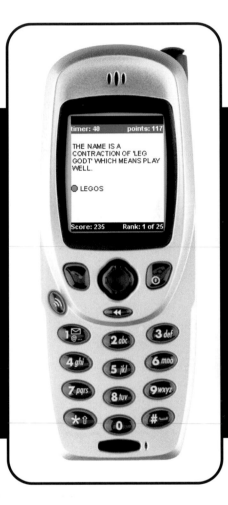

(RIGHT) **A list of high scorers displays players' screen names.**

	TOP 10	
	COUNTDOWN TRIVIA	
1	dan46	235
2	pruble	230
3	tylamma	225
4	jayqu	220
5	shashi	215
6	jaysoon	210
7	thadatak	205
8	pclarken	200
9	kevly	195
10	sweenv	190

BREW was bitmap. Some phones support color, some grayscale, and some black and white, so we had to make multiple sets of images for multiple phone types." Bitmap files are also significantly larger in size than are those of other types of images, and they eat up the limited memory resources. So, to allow for the greatest degree of flexibility, the team designed the gameplay to work with text, independently of the graphics.

On the technology side, the developers had to overcome compatibility issues, as the phone application was written in one language and the existing Buzztime server it connects to was written in Java. The project included an enormous learning curve for Buzztime's team, but they considered the end result worth it. They had proven that it was possible to deliver and manage a multiplayer, multiplatform interaction that stands out as an excellent example of cross-media convergence technology. ⊐

(RIGHT TOP) This screen shows what the same Predict-the-Play experience looked like on the Internet. While there are extra features on this platform, the main gameplay interaction remains the same.

(RIGHT BOTTOM) The same game looks like this as an iTV game for the Scientific Atlanta set-top box. The iTV version communicates slightly more information graphically, but the core game interaction is the same as that for phone players.

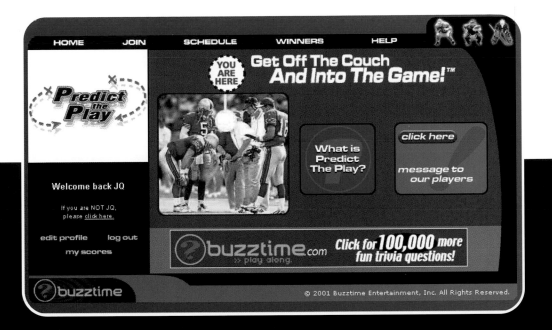

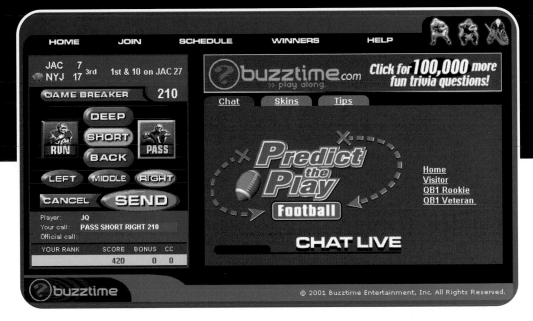

SMART APPLIANCES

By Harry West
Vice President Strategy and Innovation, Design Continuum

Smart Enough to Be Charming

We are all used to computers being smart. They are smart and a little bit boring, because that is how we wanted them to be. But now, like the high school geek who has made a name for himself, they are loosening up a bit. They have achieved success and don't have to prove how smart they are anymore. No longer restricted to working long hours at the office, they want to have a life. They want to get out a little, hang out with the cool people, or maybe just spend some time at home with the kids.

The chips that made computers so smart are now finding their way into other things in our lives. Things we have known and loved for a long time as dumb devices have smartened up. They can communicate with you, sense things for themselves, and don't have to be told what to do all the time. They can go where you go because they aren't as tied down with cables and cords as they used to be. The interface to a computer is the screen, but for these new smart devices, the entire product is the interface.

Take a prosaic example: a blender. When Fred Waring brought the blender into our world in 1937, it was a pretty dumb device. You could make a lot with a blender, but you had to know how to use it. You used to have to know the recipes in order to make salsa, pesto, and, of course, my favorite cocktail-party staple, the margarita. There was an art to getting the consistency right. You could be proud of your mastery of your blender. Sixty-three years later, Oster introduced the In2itive blender, which has the smarts to know how to blend different recipes. Now that anybody can get it right, the intrinsic satisfaction of exercising your blending skill is gone, but you can blend with confidence and you can try out new recipes with success.

OK, so now I have a know-it-all blender. Does that ▶

[MICROWAVE] **Primary interface: a button**

make me feel better? Or has it become like those know-it-all people who we sometimes encounter at cocktail parties? They seem to know everything, but you don't enjoy talking with them. Their smartness doesn't make you feel better. It makes you feel inadequate, bored, and you start looking around for someone else to talk to. We don't necessarily enjoy interacting with smart people. Other people's cleverness is not interesting to most of us.

People who are charming are not just smart; they also engage you. They don't just respond with correct but simplistic answers to your questions, they connect with you and make you part of the subject of the conversation. And they engage you visually as well as verbally. Words alone are not enough for a great conversation. There is also the way a person looks you in the eye, and those other subtle cues that say, "I'm listening and I'm interested in what you are saying." And, let's face it, their appearance matters, too. Some people are fascinating to be with even when they are saying nothing. Their face or the way they carry themselves compels you to look at them, and whatever they say, no matter how quietly, no

(SPUTMIC) **Primary interface: a shape**

matter how simply, you find compelling. You nod your head, because you are happy to have been spoken to by this person, and to have been part of the conversation.

So how can we create products that are not just smart, but also charming? What are the basic elements of charm? Well, first there is the art of knowing when to engage. Sometimes people are open to an intimate conversation, and other times they need just a moment's help. The charm is in the brevity and completeness of the exchange. Let's call this the "pass the salt test." At a dinner party, if someone asks you to pass the salt, it is nice if you do exactly that. The request is not necessarily an opening for an extended conversation. Not a big deal, just pass the damn salt, if you please. Then we can all get on with what we were doing.

Samsung microwave

So many products today incorporate sensors that simplify our interaction with them. Clothes dryers can sense when your clothes are dry. Microwaves can sense when your food is warm. This makes interacting with the appliance simpler. Now you can just ask your dryer to dry your clothes, or your microwave to ▶

heat your food. You don't have to engage in advising your appliance on how to go about doing its job by suggesting times and temperatures. It is smart enough to know what to do, and as a result the interface can be so much simpler. For many people, just one button will do. Dry. Heat.

Then there is the art of being approachable. How people connect with you depends on the cues you provide. First impressions are skin-deep. Do you look approachable and fun? How is a person who has not met you before going to first engage with you? If you are new and different, then you need to help other people know how to connect with you.

Sputmic

Question-and-answer times at large professional meetings are often awkward occasions with staff running around handing out microphones so that people can be heard. Ted Selker from MIT's Media Lab proposed a very simple solution to the problem—a microphone that you can throw from person to person. That is easy, but

(BLENDER) **Primary interface: LCD screen, buttons**

how do you make sure the person on the other end is going to catch it? A person in the audience probably hasn't seen or heard about this technique before, and now the microphone is flying toward them and they have a fraction of a second to understand what to do. Fortunately, Sputmic is almost impossible to drop, and once it is in your hands you just talk to the glowing spike, and you have succeeded.

After you first connect with someone, how do you maintain the conversation? You have to have something to say that is relevant to what the other person is interested in. You can ask questions, but not too many. Don't go off like a compulsive three-year-old. You can introduce a new subject if it is connected to the ▶

general area of conversation. Your conversation partners can be gently exposed to new ways of doing things and be grateful for the new ideas you have brought to their attention.

Oster In2itive blender

Most of us like to be able to do new things, but often we don't have the time to learn, or the information we need is not available at the time we need it. Making everyday devices smart brings learning opportunities to everyday activities. Maybe I bought this blender for making margaritas—that is the only thing I know how to make—but my blender exposes me to a whole new world of culinary ideas. More complicated recipes like Salsa Verde, Cuban Black Bean Soup, and… daiquiris. Not only is my blender smart, but I feel smarter, too.

Then, as you get to know someone a little better, the conversation might get more intimate. You might begin to spend a lot of time together, and through

experience you might develop your own style of communication, your own shorthand. The way you relate is no longer just verbal, or visual, but also physical. How you fit becomes important, as is your response to your partner's touch and caresses. You find that you are inseparable and that your connection is complete.

Cell phone

A cell phone has the most intimate relationship with us of any smart product. We go with it wherever it goes. We hold it to our face and whisper to it our most private thoughts. It has learned our shorthand for calling different people. In idle moments, we might talk to it or play games with it. We recognize the sound of its voice from afar. The fact that everyone around us has a phone doesn't make our relationship with our phone any less special. Our phone's connection with us is through words, sounds, and touch. Of all of our smart devices, it is our most complete connection.]

(CELL PHONE) **Primary interface: everything**

GLOSSARY

[aspect ratio] The width-to-height ratio of the picture frame. TV images have a 4:3 (1.33:1) aspect ratio, digital television will have a 16:9 (1.78:1) ratio, and most feature films have at least a 1.85:1 ratio.

[bandwidth] A relative range of frequencies that can carry a signal over a transmission medium without distortion.

[broadband] A high-bandwidth network used by Internet and cable television providers. Broadband networks have proliferated as consumers switch from dial-up connections to DSL and cable modems.

[cable modem] A device that permits one- or two-way high-speed data communication over a cable television system for purposes such as Internet access.

[cable television] The system network for the transmission of television signals and digital data through coaxial, twisted pair, or fiber-optic cables.

[compression] Reduction of the size of digital files to be stored or transmitted in order to save transmission time, storage space, or capacity.

[digital video recorder (DVR)] A high-capacity computer hard drive embedded in a set-top box that records video programming from a television set. DVRs are operated by video recording software that enables the viewer to pause, fast forward, and manage all sorts of other functions and special applications. TiVo, ReplayTV, and UltimateTV are all DVRs.

[electronic programming guide (EPG)] An interactive application used by the viewer to select television programming. Currently, EPGs also allow the user to access summaries of shows, set recording times, display program lengths, and view program choices by category. EPGs ultimately will make it possible for TV sets to suggest viewing schedules based on their users' viewing habits. ▶

[enhanced television (ETV)] A type of interactive-television technology favored by network broadcasters. This technology allows content producers to send HTML data and graphical "enhancements." On a television equipped with a special set-top box and appropriate software, these enhancements appear as overlays on the television screen that viewers can click on to interact with the Internet.

[graphical user interface (GUI)] A computing term referring to an operating system or on-screen environment that displays options to the viewer as graphical symbols, icons, or photographs.

[handheld personal computer] A device or personal digital assistant small enough to be used while you hold it to wirelessly access E-mail, paging messages, and the Internet or intranets.

[high-definition television (HDTV)] A television signal resolution higher than that of the conventional TV signal. HDTV uses a digital format for the transmission and reception of TV signals, which includes about five times more picture information (picture elements or pixels) than conventional television, thereby increasing clarity, widening the aspect ratio, and providing digital-quality sound.

[Hypertext Markup Language (HTML)] A software language used to write Web pages and hyperlinks.

[interface] A set of textual or graphical symbols that allows a computer user to communicate with the underlying software. Computer interfaces work in many ways. Some are text-based, others are graphical and require the use of a mouse, and some are touch-screen activated. ▶

[MPEG [Moving Picture Experts Group]] An International Organization for Standardization protocol for digital video and audio compression of moving images. MPEG created the standards MPEG-1, -2, and -4, which specify three different resolution formats for digital video and audio.

[on-demand] The ability to request that video, audio, or other data be immediately transmitted to the user by clicking on a command on the screen.

[pay-per-use] A system of payment for individual services, products, and downloads that often is based on tiered fees.

[personal digital assistant [PDA]] A wireless handheld device capable of transmitting and receiving data for paging, data messaging, E-mail, and other information-handling tasks.

[personal video recording [PVR]] A combination of interactive software and data services that present an electronic programming guide to the viewer, who then selects what he or she wants to watch or record on a digital video recorder. The PVR provider generates electronic programming guides daily. Leading companies that provide this technology include ReplayTV, TiVo, and others, such as WebTV and DirecTV, that include hard drives in their boxes and digital receivers for recording programs.

[picture-in-picture] A feature that gives users the ability to view two television broadcasts at a time, one in a small window on top of the other on the main screen or within a larger interactive interface.

[set-top box] An electronic device that connects a television to cable and gaming systems and the Internet. ▶

【 short messaging service (SMS) 】
A service that sends short text messages between
cell phones.

【 synchronized television (SyncTV) 】
Also called *two-screen TV*, this term refers to a television
program and an Internet application developed to be
used in conjunction with each other.

【 t-commerce 】 A word based on *e-commerce*,
this term describes the sale and purchasing of goods
and services through interactive television.

【 video-on-demand (VOD) 】 A service that
allows a user to interactively select and view videos when
desired.

【 voice activation 】 A feature of some cellular
phones that allows the user to place a telephone call by
saying, rather than entering, the telephone number.

【 voice recognition 】 A feature of cellular
phones, PCs, and other communications devices that
lets the user activate or control the device's operation
with voice commands.

【 wireless 】 A term used to describe a device or activity that uses the radio-frequency spectrum to trans-
mit and receive voice, data, and video signals.

【 Wireless Application Protocol (WAP) 】 A proposed set of standards for the way in which
wireless applications can be used to access the Internet that is designed to simplify how wireless-device users
perform tasks and receive data.

【 wireless Internet 】 A connection or method of connecting to the Internet that uses the radio-frequency
spectrum to transmit data.

【 3G 】 The third generation of wireless technology that will extend the usage of wireless devices beyond
personal communications services.

【 802.11 】 The Institute of Electrical and Electronics Engineers standard for wireless local area network
interoperability. 】

ACKNOWLEDGMENTS

First, and most importantly, thanks to my wife, Elizabeth, who helped me throughout the production of this book, for all her love and support.

Thanks to all of the talented artists, programmers, and visionaries whose exceptional creations are exhibited in this book.

Thanks in particular to Tracy Fullerton of Spiderdance; Mellisa Holden, Dan Sellars, and all the AGENCY.COM people; Vlad Cohen of the BBC; Dale Herigstad and Robert Sanborn of H Design; Steve Armstrong and Michael Waters of ARTiFACT; and Karen Spiegel of R/GA Interactive, Anna Marie Piersimoni of the AFI; Harry West of Design Continuum; Justin Hewelt of Broadbandbananas.com; Terri Swartz and Ryan McMeniman of Navic Systems, Rob Kramer of ASU, and Miki Nakajima of DoCoMo for all of your contributions to this project.

At Rockport, I am indebted to Claire MacMaster, Winnie Prentiss, Nancy Elgin (for making sense of my writing), John Hall for the excellent book design, and most of all, Kristin Ellison, who pushed me to make this a better book.

Special thanks to Mike Gauthier, who encouraged me to pursue this project, John Lione, Nicole Johnson, and all of the staff at e-tractions, who put up with my night job. ⊃

DIRECTORY

AGENCY.COM
20 Exchange Place
New York, NY 10005
www.agency.com

ARTiFACT [+] iTV
725 Arizona Avenue, Suite 103
Santa Monica, CA 90401
(301) 319-1390
www.artifactinc.com

BBC Interactive
Bush House
PO Box 76
Strand
London WC2B 4PH
England

**Buzztime
Entertainment Inc.**
5966 La Place Court, Suite 100
Carlsbad, CA 92008
(760) 476-1976

Design Continuum
1220 Washington Street
West Newton, MA 02465-2147
info@dcontinuum

NTT DoCoMo, Inc.
11-1 Nagata-cho 2-chome, Chiyoda-ku
Tokyo 100-6150, Japan
81 (0) 3 5156 1111
www.nttdocomo.com

e-tractions
4 Preston Court
Bedford, MA 01730
www.e-tractions.com

H Design Inc.
6525 West Sunset Boulevard, 6th Floor
Hollywood, CA 90028
www.hdesigninc.com

Heavy
330 West 38th Street, Suite 1102
New York, NY 10018
www.heavy.com
www.heavyindustry.net

Pod Design Inc.
2 Vine Street
Lexington, MA 02420
www.poddesign.com

R/GA Interactive
350 West 39th Street
New York, NY 10018
www.rga.com

Spiderdance
100 Market Street
Venice, CA 90291
www.spiderdance.com

INDUSTRY LINKS
www.broadbandbananas.com
www.itvt.com
www.afi.com

ABOUT THE AUTHOR

Steve Curran is principal of Boston-based Pod Design and has been creative director of Interactive Marketing and Entertainment for over twelve years. He has worked at Random House as a designer, was vice president of Creative Development for video-game publisher/developer Gametek Inc., and was a founder and creative director of Pod, a Miami-based multimedia studio, and of e-tractions, a Boston-based online game and promotion company.

He has designed and directed award-winning video games, motion graphics, kiosks, CD-ROMs, and Web sites for international clients including The History Channel, Shell Oil Corporation, Sony Entertainment, The Weather Channel Latin America, Babor Cosmetics, Blockbuster Entertainment, Johnson and Johnson, and Parametric Technologies Corp.

Curran is the author of *Motion Graphics* (Rockport, 2000).

He resides in Lexington, Massachusetts, with his wife, Elizabeth, and sons Jake and Christopher. 〕